IMAGES
of America

ITALIANS IN THE
SANTA CLARA VALLEY

IMAGES
of America

ITALIANS IN THE
SANTA CLARA VALLEY

Frederick W. Marrazzo

ARCADIA
PUBLISHING

Published by Arcadia Publishing
Charleston SC, Chicago IL, Portsmouth NH, San Francisco CA

Printed in the United States of America

Library of Congress Catalog Card Number: 2007928547

For all general information contact Arcadia Publishing at:
Telephone 843-853-2070
Fax 843-853-0044
E-mail sales@arcadiapublishing.com
For customer service and orders:
Toll-Free 1-888-313-2665

Visit us on the Internet at www.arcadiapublishing.com

Dedicated in memoriam to my grandparents Joseph and Laura Marrazzo, whose Italian heritage is a gift I have come to appreciate more each day.

CONTENTS

ACKNOWLEDGMENTS

This book could not have been done without the financial and moral support of my wife, Rika. Her enthusiasm for Italian culture and heritage has shown me the gift that it truly is. Her quiet influence will no doubt be felt by many. I would also like to thank Lawrence DiStasi for his insights and scholarship on what it means to be of Italian heritage. He has inspired me to explore the topic further than I ever thought I would.

A word of appreciation must go to Barbara Kinchen from the Mountain View Library History Center for her initial assistance and encouragement.

Also instrumental in their willingness to reminisce and make key introductions to those who could help were Mae Ferraro and Frank Tricomo, both true historians in their own right. I thank them for their enthusiasm and great interest in this project. My thanks to Dan Palermo and Sam Cancilla of the Italian Men's Club for allowing me to address the membership during their weekly Monday lunch-bingo gatherings. I met many wonderful people who made me feel welcome and offered suggestions. Thanks also to Carlo Marenco, John Salamida Sr., Pat Taormina, and Aldo Ausano for a chance to address their respective organizations about the project.

Brothers Joe and Anthony Quartuccio are to be thanked for their encouragement and support. Other individuals who offered insights, suggestions, and/or reading materials to help with my research include Monte Antichi, Tony Moreali, Nick Lickwar, Ken Blase, Joe Filice, Frank Locicero III, Judy Verona Joseph, David G. Ferrari, John Linda, Tish Picchetti, John D'Ambrosio, Larry J. Marsalli, Sal Falcone, Vince Falcone, Lisa Christiansen, Ralph Pearce, Donna Austin, Kristin McCaman, Lucy Solorzano, Jon J. Campisi, Dr. Victor Vari, Tony Zerbo, Carmela Gullo, Terry Stevens, Matt Cusimano, Louis D. Riga, Andy LaScola, Dave Leonard, Kay Gemello, and Sam Bozzo. Thanks to everyone for their suggestions along the way.

I especially want to acknowledge all those who allowed me to come into their homes and scan photographs for this book. I thank you for your kindness and willingness to share your memories with me and the larger community. Without you, there simply would be no book. As they say, a picture is worth a thousand words. Thanks for speaking up.

Last but not least, I want to thank Devon Weston and the good people at Arcadia Publishing for making this project happen. Their appreciation for cultural heritage and local history is truly inspirational.

INTRODUCTION

The idea and inspiration for this book came to me after I did an interview with Lawrence DiStasi, an author of an important book on the evacuation and internment of Italian Americans during World War II. I interviewed DiStasi on my self-produced public access television program called *Cronaca*, which means "story" in Italian. One of the topics that we discussed during the interview was a piece of legislation called the Wartime Violation of Italian American Civil Liberties Act of 2000, also known as Public Law 106-451. It is essentially an acknowledgment by the U.S. government of its mistreatment of the Italian community in America during World War II. Not many people know about this because not many people have wanted to talk about it.

The lesson from the DiStasi interview was that having an open discussion about Italian heritage has benefits. My next project was a small documentary video called *Forgotten Voices: Italian Americans of the Santa Clara Valley*, which included a series of 10 interviews with individuals of Italian descent about what it meant to them to be of Italian heritage. Hearing them talk about their experiences inspired me even further. The publisher of this book was at first skeptical as to whether the number of Italians in Santa Clara County was sufficient to justify a book. However, the closer I looked, the more apparent it became that the Italian community did in fact play a significant role in the development of the Santa Clara Valley. Initial evidence of the Italian community's presence can be seen in some of the social clubs that still exist. These include groups such as the Civic Club of San Jose, the Trabia Club, the Tricarico Club, the Sons of Sicily, the Order Sons of Italy, the Figli di Calabria, the Amici D'Oro, the Italian Catholic Federation, the FBI Club (Full-Blooded Italians), the Italian Men's Club, and the Italian American Heritage Foundation. Yet the story of the Italians has often been overlooked, to the point of being invisible and forgotten.

Since few of the museums or historical societies seemed to have any kind of collection of photographs about the local Italian community, the author went directly to individuals to ask them to share their photographs and stories. They related firsthand impressions of how things once were. Italians are natural storytellers who speak with pride and humor. The photographs in this book are their stories. They are the real historians. The photographs presented here are just a small snapshot of the overall Italian community of the Santa Clara Valley.

Throughout my conversations, it became clear that the Italians were a big part of the Santa Clara Valley's agricultural development. Many families worked for the numerous canneries that turned the valley's abundance of apricots, prunes, cherries, and peaches into canned products that were eventually shipped to the East Coast and other points outside of the states. I spoke to many who remembered when the Santa Clara Valley was nothing but countryside and the neighboring big city was San Francisco. Italian families like Bisceglia, Filice, Perrelli, LoBue, Perrucci, DiNapoli, Greco, and Barbaccia were instrumental in providing jobs for thousands of people and for feeding millions through their canned food products. You will also see names of local Italian Americans who are less well known but whose contributions nevertheless have had a collective impact on the lives of many.

In addition to working in the canneries, the Italians also took jobs as laborers, teamsters, seamstresses, meat cutters, stonemasons, bootblacks, orchardists, vineyardists, farmers, tinners, machinists, scavengers, peddlers, drivers, and others. Their industriousness, ingenuity, creativity, and perseverance helped to create a dynamic economy and society that has since been emulated by many nations around the world. The above qualities that they demonstrated are exactly what made them great citizens of their community and great Americans.

What the book also illustrates is that the early Italian immigrants of the Santa Clara Valley came from all parts of the Italian peninsula, which included Piedmont and Tuscany in the north to Sicily and Calabria in the south. Unification of the Italian peninsula by Giuseppe Garibaldi in 1860 led to the formation of the Kingdom of Italy in 1870. The Republic of Italy was not formed until 1946. What few people realize is that the idea of an Italian nation is a relatively new construction. Political and economic upheaval caused many "Italians" to go abroad to seek economic relief. Since Italy was a relatively new concept, few "Italians" really considered themselves Italian. They tended to identify themselves mainly with the villages where they were born. A culture of "campanilismo," which refers to trusting only those who came from your ancestral village, was the orientation among many Italian immigrants. It is this regional diversity found throughout Italy that helps to explain the diversity of the Italian community in the Santa Clara Valley.

The valley initially attracted many Italians because it reminded them of their villages in Italy. Furthermore, the local climate was similar to many parts of Italy. With the spread of Catholicism by the Spanish missionaries through California, it is not surprising that some of the towns in Santa Clara County are named after religious icons of Italy, which is home to the Pope and the Roman Catholic Church. Santa Clara is named after St. Claire of Assisi, Italy, just as Cupertino was named after St. Joseph of Copertino, Italy. It is worth pointing out that a trinity of three churches in San Jose once served the spiritual needs of a good portion of the Italian community. They included Holy Cross, Holy Family, and Sacred Heart. With the gradual decline of the Italian population in Santa Clara County, only Holy Cross Church still holds one mass in Italian.

People like A. P. Giannini, who was born in San Jose and founded the Bank of Italy, which later became the Bank of America, are part of the history of the local Italian community. His contribution to the Santa Clara Valley was found in his willingness to help the "little guy" who needed banking services to succeed. Other key figures of the Italian community were people like Dismo Mario Denegri, who was considered the most able leader that the Italian American community ever had. He stood up for the rights and dignity of the community when it needed leadership. And yet his name is not well known today. Sadly, there are others like him who have made contributions that remain obscured.

In the course of this project, I have been reminded that it really is all about telling the story. Stories are told in a variety of ways—movies, books, newspapers, magazines, photographs, art, music, architecture, and more. They all aim to teach us something new or remind us of something we may have forgotten. One of the big stories here is the values and faith that the older generation of Italians shared with each other and with their community. It is a story that we need to share with others and with ourselves before we forget. One message that the author hopes readers will hear is that history only remembers those who remember themselves. Let's not forget.

One
GETTING STARTED

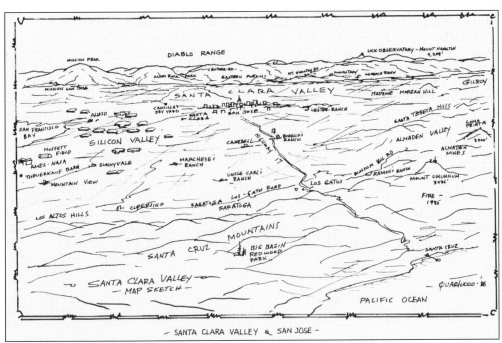

Santa Clara County was named after St. Claire, who was born Chiara Offreduccio on July 16, 1194, in Assisi, Italy. She was one of the first followers of Francis of Assisi and founded the Order of Poor Ladies for women who chose to take the Franciscan vow of poverty and celibacy. This bird's-eye sketch of the Santa Clara Valley was done in 1986 by Anthony Quartuccio Sr. (Courtesy Anthony Quartuccio Sr.)

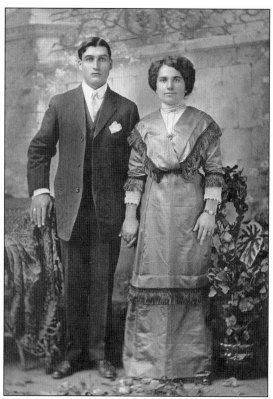

Peter and Gina Basso pose for their wedding photograph in 1912 in Turin, Italy. While the industrial north generally tended to be better off financially than the agrarian south, Italians immigrated to America from all parts of Italy. Italy did not become a single nation until 1870, after Giuseppe Garibaldi had unified the Italian peninsula with Sicily in 1860. (Courtesy Jim Basso.)

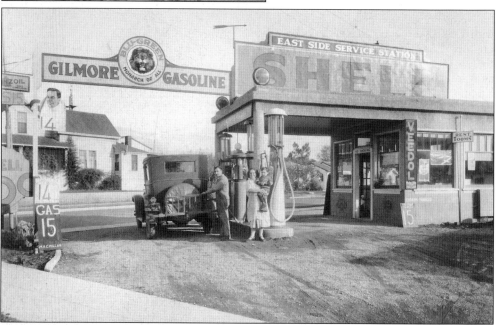

Gina Basso holds her son Jim as her husband, Peter, attends to a customer at their East Side Service Station at the corner of Santa Clara and Thirty-fourth Streets sometime around 1932, the height of the Great Depression. According to the sign, gas was 15¢ per gallon, and Gilmore Blu-Green gasoline was all the rage. (Courtesy Jim Basso.)

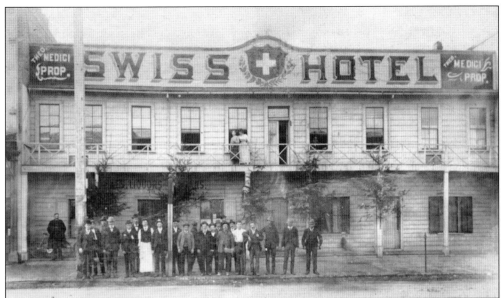

The 22-room Swiss Hotel was leased and operated by Luigi Giannini, who found his way to San Jose in 1869. Many Italian immigrants got started by staying at hotels like this. Obstacles that Italian men had to struggle with included learning English while also learning the customs of a new land far away from home. (Courtesy Virginia Hammerness.)

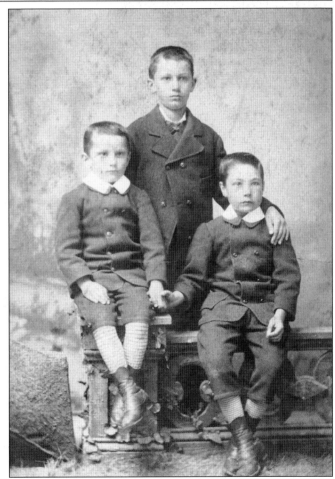

Amadeo Peter (A. P.) Giannini (center) is seen here with his brothers George (left) and Attilio in 1880. A. P. was born in 1870 in San Jose to Luigi Giannini and Virginia Demartini. Three years before this photograph was taken, A. P. had witnessed his father's murder at the hands of a disgruntled workman over a "one dollar" debt. Giannini vowed never to be controlled by money. (Courtesy Virginia Hammerness.)

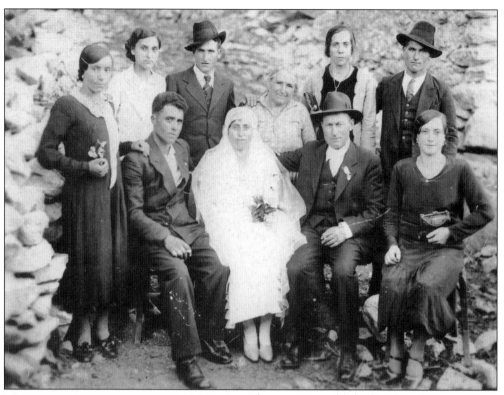

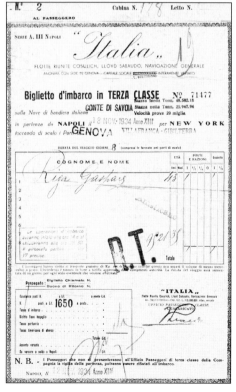

After getting established in America, many Italian men would then return to Italy to get married, bringing their new brides back and starting their families. Several years of separation from loved ones in Italy was the norm. Seated in the center are Gaspare Riga (wearing the hat) and his new bride, Antonia Pietrantoni, on their wedding day in Italy in 1934. (Courtesy Louis D. Riga.)

After returning to Italy in 1934 to get married, Gaspare Riga returned to America via New York aboard the ship *Count of Savoy*. This round-trip, third-class ticket indicates that the ship departed from the port of Naples and was scheduled for a port of call in Genoa. The duration of the voyage was expected to take eight days. (Courtesy Louis D. Riga.)

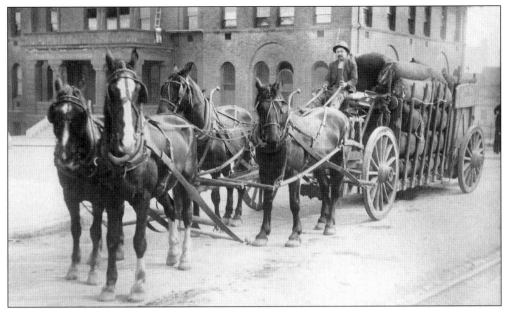

Emilio Guglielmo is seen here around 1910 as a team driver for Frank's Tannery in Redwood City. By 1925, Emilio and his wife, Emilia, had saved enough money to purchase some land in Morgan Hill to start their own winery. Not even Prohibition could deter Guglielmo from starting his business, which continues today under the leadership of his three grandsons—Gene, George, and Gary. (Courtesy Gene Guglielmo.)

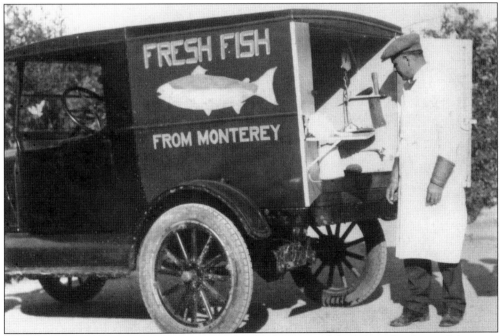

On Fridays, Sal Guido would start his day around 2:00 a.m. and drive from San Jose to Monterey to buy fish from the Sicilian fishermen. By the time he returned to San Jose around 10:30 a.m., he would drive over to the "Goosetown" section and sell the day's catch to the many Italian families who lived in the area. (Courtesy Gene Guido.)

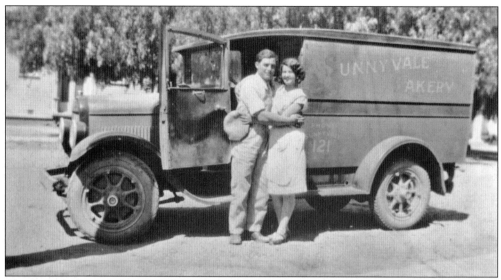

Charles Rifredi started out as a delivery driver for the Sunnyvale Bakery in 1922. After he and Adriana Quinterno were married in 1929, the couple started their own grocery store in the early 1930s. With Charlie as butcher and Adriana managing the finances, they built Rifredi's Market in "downtown" Monta Vista. Adriana Avenue, where prune orchards once existed, is named after Adriana Quinterno. (Courtesy Paula Quinterno.)

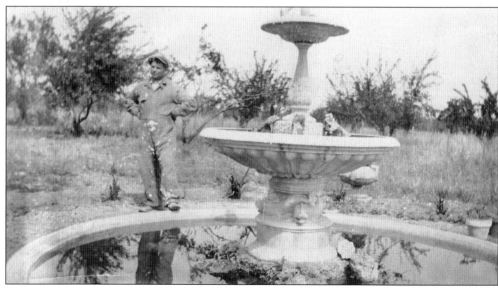

Federico Quinterno was an artist, sculptor, and stonemason who came from the Piedmont region in northern Italy in 1913 with his wife, Francesca, and their three children, Adriana, Nellie, and Angelo. Here Federico is seen standing in front of the fountain that he built for his own home on Pasadena Avenue in Cupertino in the early 1920s. The orchards can be seen in the background. (Courtesy Paula Quinterno.)

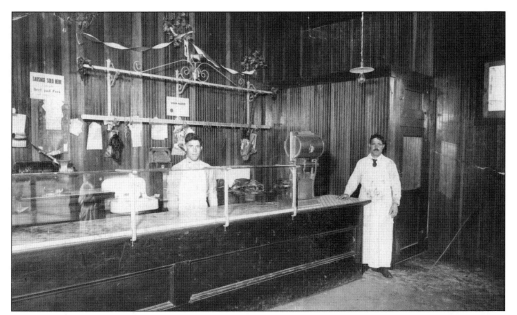

Salvatore Chiaramonte (right) immigrated with his family from Trabia, a small town in the province of Palermo on the island of Sicily, to San Jose in 1904. The Chiaramonte family opened their market on North Thirteenth Street in San Jose in 1908. Lou Chiaramonte continues to make the same Italian sausage that his great-grandfather started making in 1915 in the same location. This photograph was taken in 1920. (Courtesy Lou Chiaramonte.)

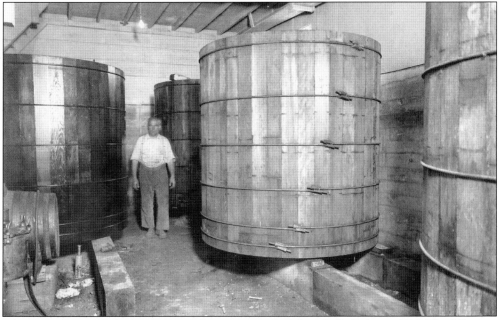

John Gemello established a winery in Cupertino on the Montebello Ridge in 1915. The following year, his son Mario was born. By 1925, however, Prohibition had made it very difficult to make a living selling wine. John tried starting his winery again in 1933, and he succeeded. Pictured here in 1939 is John at his Gemello Winery at 2003 El Camino Real. The winery was sold in 1982. (Courtesy Sally Traverso.)

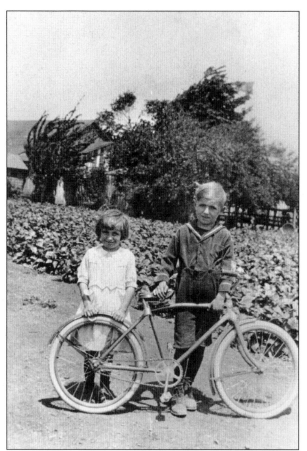

Seen here in 1925 are Sally Gemello and her brother Mario with what looks like a new bicycle. Prohibition had forced the children's father to abandon winemaking temporarily and move into vegetable farming. Mario's father later started the Gemello Winery on this property in Mountain View and gave it to Mario to run in 1944. (Courtesy Sally Traverso.)

Many Italian immigrants had very little formal education when they first started coming to the Santa Clara Valley in large numbers starting in the 1880s. This 1904 photograph of the Dear Old Brown School in the Santa Cruz mountains shows several members of the Panighetti family with their teacher, a Miss Fiskas, on the left. (Courtesy Paula Quinterno.)

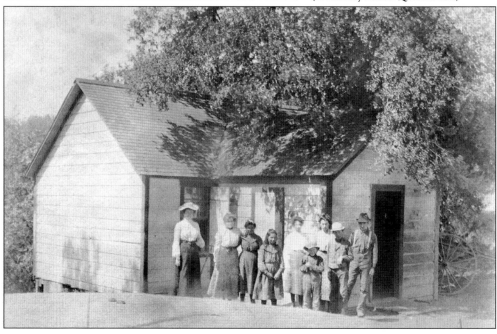

Vince Cala is here with his father, Salvatore, in 1931. Salvatore came to San Jose in 1921 from the small town of Mussomeli in the province of Caltanissetta on the island of Sicily. Salvatore worked for a nursery in Palo Alto where he stayed for six years and became a foreman. He married Filomena Filice of Gilroy, and together they bought a 10-acre cherry orchard in Sunnyvale. (Courtesy Vince Cala.)

Vincenso Picchetti was one of the earliest Italian settlers to the Santa Clara Valley. Born in 1848 in the northern Italian province of Formarco, Picchetti came to the Santa Clara Valley in 1872 and worked for the Jesuits at Villa Maria in Cupertino at the base of Montebello. By the time Vincenso died at the age of 56 in 1904, he had acquired about 500 acres on the ridge. (Courtesy Hector Picchetti.)

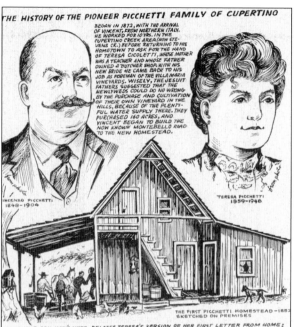

This Peter Emig sketch of Vincenso and Teresa Picchetti relates the story of how homesick Teresa was after she had first arrived in Cupertino in 1882 with her new husband. It took several months for a letter from her father in Italy to arrive. In addition to other contributions to their new community, the Picchettis were instrumental in establishing the Montebello School in 1892. (Courtesy Cupertino Historical Museum.)

John Cimino sits in his shoe repair shop in 1915 in the nickel-mining town known as the Creighton Mine unit in Sudbury, Ontario, Canada. Restrictions on immigration from Italy directly to the United States forced many Italians like Cimino to seek citizenship in Canada. Once he became a citizen of Canada, John eventually made his way to Gilroy to stay with an aunt. (Courtesy Bunny Filice.)

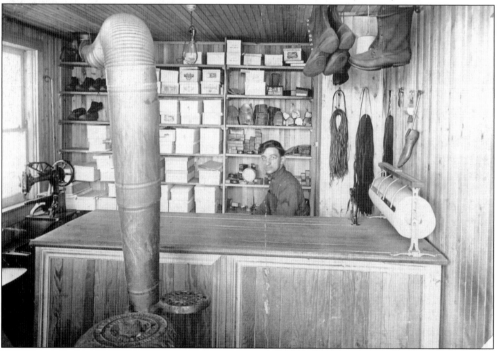

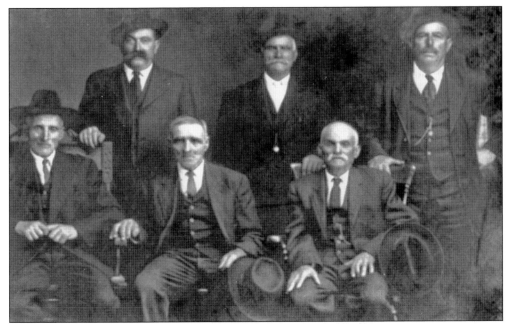

Some of the Italian patriarchs in 1922 who came from Calabria, Italy, to settle in Gilroy include, from left to right, (first row) Peter Filice, Gennaro Filice, and Michael Filice; (second row) Philip Perrelli, Bruno Filice, and Michael Filice. Note that two of the men are named Michael Filice; it was common for many relatives to have the same first name. Nicknames were commonly used to avoid confusion. (Courtesy Bunny Filice.)

Married in 1951, Adolph and Esther De Mattei soon became proud parents of daughters Nancy (second from left) and Linda. Adolph was born on East Taylor Street, where his family had a cherry orchard. Adolph's father, Silvio De Mattei, was one of the original five board members of the Grower's Market at Seventh and Taylor Streets. Esther was born on Almaden Avenue, and her father ran the Parisian Delicatessen on San Fernando Street for 45 years. (Courtesy Adolph and Esther De Mattei.)

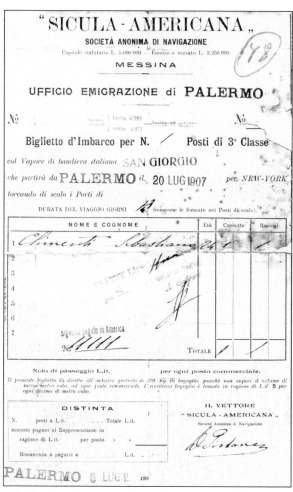

This third-class boat ticket shows that Sebastian Chimenti left Italy in 1907 from the port of Palermo, Sicily, to come to Ellis Island in New York. The name of the ship was the *San Giorgio*, and the duration of the trip, including stops at ports of call, was expected to take 13 days. Those immigrants who arrived in ill health were put back on the next ship bound for Italy. (Courtesy Lucille Basso.)

Sebastian Chimenti is pictured here in 1937 with a "Fresh Fish" sign, which he set up on the back of his car. This was one way to earn a little extra money—by providing a convenient service for his customers, especially on Fridays, when Italian Catholics usually ate fish. (Courtesy Lucille Basso.)

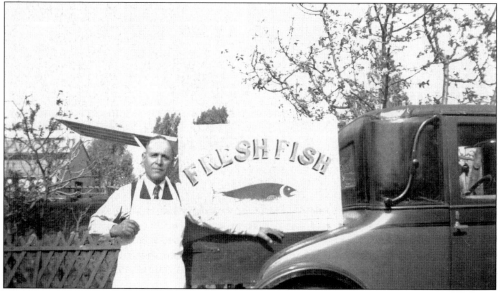

Two

FARM LIFE

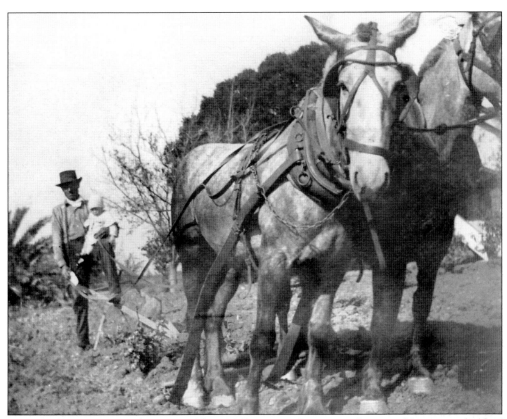

Many Italians came to the Santa Clara Valley to work in agriculture and buy some land of their own. Angelo Bellicitti came from the small town of Porcari in Italy's northern province of Lucca. Here he holds his baby son, Harry, while the plough team, Buster and Topsy, take a break from their farming duties at the Pollard Road ranch in Saratoga in the early 1920s. (Courtesy Harry Bellicitti.)

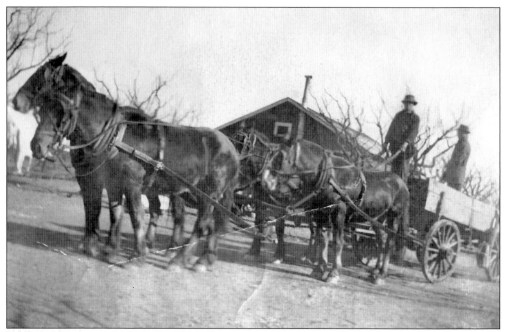

Angelo Bellicitti is seen here preparing his team to make a run from his Saratoga ranch into San Jose. In the 1920s, such a trip was considered an all-day affair, from sunup to sundown. Before heading out, the cart was usually loaded with items to deliver to customers. After it was emptied, it would be refilled with supplies to bring back to the farm. (Courtesy Harry Bellicitti.)

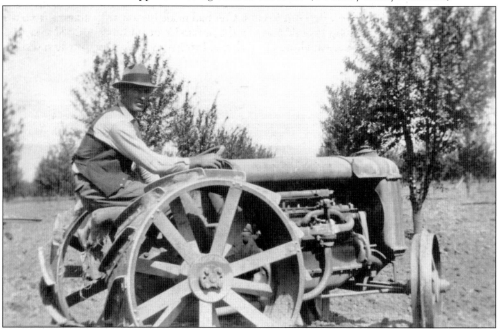

By 1929, Angelo Bellicitti was using a tractor to plow his fields. Many Italians worked as farmers and orchardists throughout the valley, which had some of the most fertile farmland anywhere in the world. Known also as the "prune capital of the world," Santa Clara County was a haven for the farming skills of many Italian immigrants. (Courtesy Harry Bellicitti.)

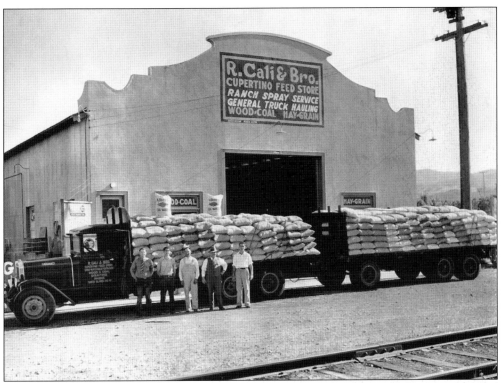

R. Cali and Brother in Cupertino was a typical food and fuel shop that sold dairy, poultry, and rabbit feeds and wood and coal. By 1907, Rosario Cali had made his way to California from the province of Catanio, Sicily, Italy, to build roads for the Suisun Cement Company for $2 a day plus board. He and his brother Sam established R. Cali and Brother in 1922. (Courtesy Ron Cali.)

The Cali brothers' mill was located at the intersection of DeAnza Boulevard and Stevens Creek Road when it was just a dirt road. Standing at the historic crossroads today is the Cali Mill Plaza, which consists of a hotel and shopping complex. Rosario's grandson Ron Cali, who was named Citizen of the Year in March 2006, continues to be an active member of the Cupertino community. (Courtesy Ron Cali.)

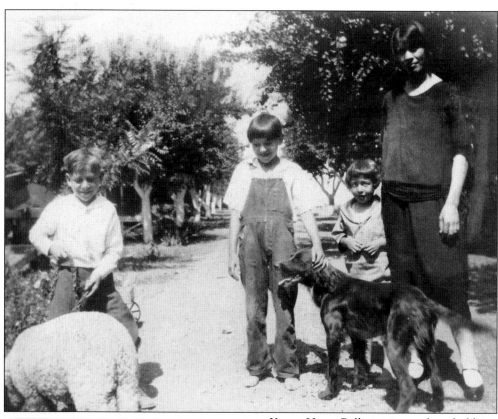

Young Harry Bellicitti is seen here holding onto the sheep at his family's Allendale Road home sometime in the late 1920s. The woman standing at right is Harry's Aunt Jemma. By the time Harry was nine years old, he was driving his father's tractor. Harry later became a machinist and served in World War II. (Courtesy Harry Bellicitti.)

A couple of baby goats get special attention from Nick Chiechi sometime in the late 1920s. Prior to being donated to Kelley Park at History San Jose in 1973, the Chiechi House was originally acquired in 1911 by Nick Chiechi's father, Michele Chiechi, whose family lived at 820 Northrup Avenue for 60 years. The Chiechi House was originally built by John and Jane Campbell in 1876. (Courtesy Marge Chiechi.)

This equine dray team helped A. P. Giannini safely move his bank assets from San Francisco to his home in San Mateo after the 1906 earthquake. A. P. borrowed Chub and Babe from his stepfather Lorenzo Scatena's commission house while chaos swirled all around them. These two horses calmly helped Giannini transport the bank's gold bars and bank records without attracting any unnecessary attention. (Courtesy Virginia Hammerness.)

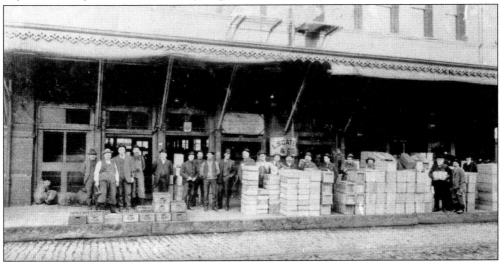

A. P. Giannini was 12 years old when he moved to San Francisco with his mother and stepfather, Lorenzo Scatena. Scatena had started out unsuccessfully as a farmer. He soon discovered that he was much better suited to being a broker of fruits and vegetables. Sometime around 1883, he started his own business, L. Scatena and Company, with A. P. Giannini by his side. (Courtesy Virginia Hammerness.)

The LoBue brothers, Mariano (left) and Vito, are seen here around 1911 at their ranch just south of San Jose. They were partners in the San Jose Canning Company, which was founded by Ignatius Rancadore in 1919. Vito LoBue is with his daughter Millie, who would later become Millie LoBue Taormino. Mariano LoBue's daughter, also named Millie, would one day become Millie LoBue Pepitone. (Courtesy Vic LoBue.)

This 1919 contract shows that Vito LoBue struck quite a deal with J. A. Turner. For the whole sum of $10, Vito would receive "About One Hundred (100) fruit boxes; three (3) large spring wagons; one (1) single Oliver steel plow; one (1) double Milpitas gang plow; one (1) five-year-old black horse, named "Chub"; one (1) five-year-old black mare, named, "Belle"; one (1) Jersey cow; one (1) set double harness; and fifteen (15) hens." It had to be the deal of the century. (Courtesy Vic LoBue.)

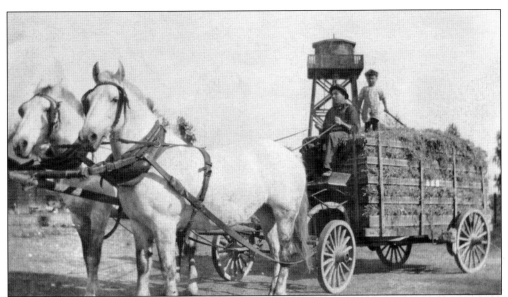

Taken sometime in the 1910s, this photograph shows Mario Orlando holding the reins while Tony Gullo stands tall on a hay-filled wagon on the Gullo Ranch, which was located on Redman Avenue between Meridian Avenue and Almaden Road. The Gullos grew prunes for nearly 30 years and helped contribute to Santa Clara County's reputation as the "prune capital of the world." (Courtesy Gene Guido.)

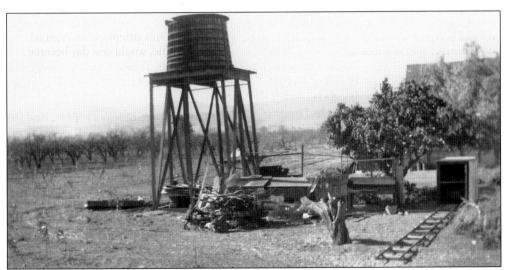

Water towers were common on many ranches throughout Santa Clara County. This particular tower was located on Carl Marchese's ranch on Johnson Avenue near Cupertino. The orchards in the background included prunes, cherries, apricots, and walnuts. In 1963, the Marchese ranch was sold and subdivided. By then, the idyllic landscape of the valley had started to change forever. (Courtesy Anthony Quartuccio Sr.)

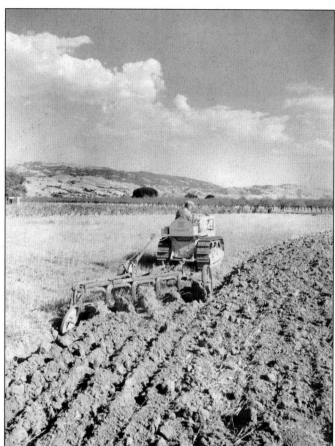

As soon as Tony Bonino graduated from the San Martin Grammar School in 1924, the first thing he did was buy a tractor and start working on the farm. Here he is seen in 1936 plowing the fields behind his home in San Martin on that very tractor. In Italy, it never would have been possible for him to own and develop this much land for farming. (Courtesy Louis Bonino.)

This is the Bonino homestead in San Martin in 1933. Behind the house were many acres of pear orchards and fields. Topsoil from runoff from surrounding dam systems such as the Anderson Dam made the valley soil fertile and made it easy for farmers to grow abundant crops. (Courtesy Louis Bonino.)

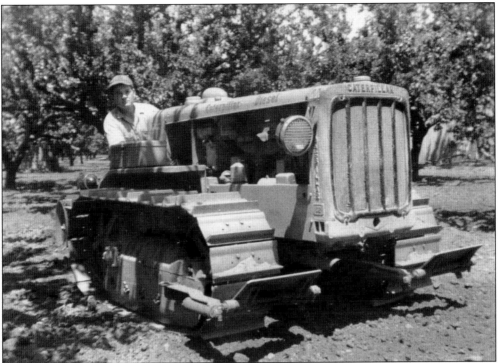

Vince Cala is pictured here in 1950 on a new Caterpillar D2 tractor plowing up his family's Sunnyvale cherry orchard. Shortly after, Vince was "drafted off the farm" and sent off to the Korean War. After he returned, he resumed his duties to help his father manage their growing operations. The Cala orchard is now a shopping complex called the Cala Center on El Camino Real. (Courtesy Vince Cala.)

This receipt for Salvatore Cala's new Caterpillar tractor shows that it cost $4,328.58 in 1949. At one point, Cala had 90 acres of orchard under his management. The Cala orchards would average around 750 tons of apricots and 75 tons of cherries per season. Two gallons of diesel would allow the tractor to work three acres per hour. (Courtesy Vince Cala.)

Caterpillar

JOHN DEERE - KILLEFER

Gilroy Telephone 727-W Hollister Telephone 860

1841 So. First St.
SAN JOSE 8, CALIFORNIA
Telephone Col. 8716 1-19-49

S. Cala
Rt.1, Box 1598
San Jose, Calif.

To One New CATERPILLAR D2 Tractor,
50" gauge, rear seat equipped
w/16" H.T.track shoes, orchard
exhaust, track carrier rollers,
track roller guards and electric
starting system. #5U2184 $4035.00
To Lights, installed. 70.00
To checkbreakers, installed 108.00
To one 178K Turning Bar. 10.00
 $4223.00
To sales tax 105.58
 $4328.58

Paid 1/20-49
C. Williams

Terms:
Net cash, due upon receipt
 of this invoice. $4328.58

29

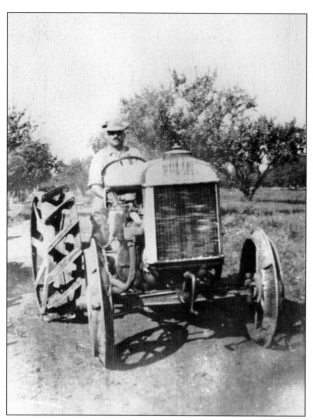

Many Italian farmers, like John Gemello, were able to purchase equipment like tractors after getting help from A. P. Giannini's Bank of Italy, later to become the Bank of America. Giannini recognized the opportunity to make money by lending to the "little guy," many of whom were fellow Italian immigrants who came to America looking for opportunities that were not available back in Italy. (Courtesy Sally Traverso.)

The Picchetti Ranch contains a complex of seven buildings built between 1880 and 1920. Vincenso and his brother Secondo were among the first settlers on a ridge, which they named Montebello or "beautiful mountain." In this photograph in front of the Picchetti ranch house in 1890, the men are holding glasses of wine. (Courtesy Hector Picchetti.)

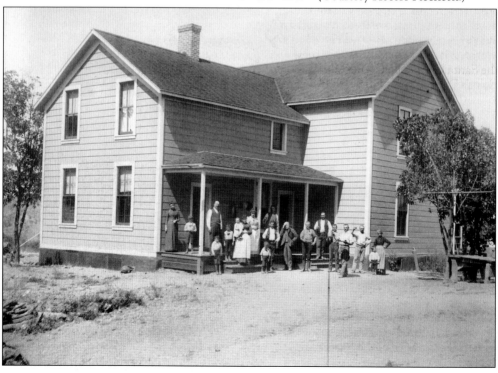

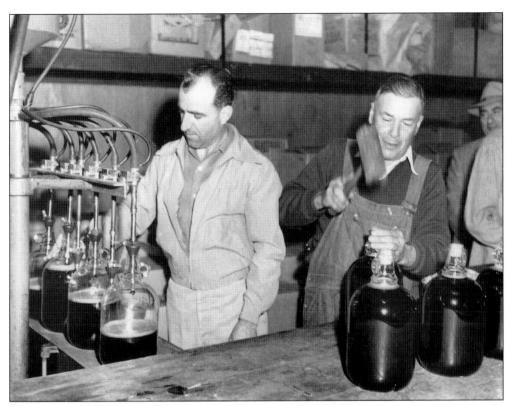

Mario Gemello fills jugs at his winery on El Camino Real in 1951 while an unidentified man hammers in corks. Born in 1916, a year after his father moved from northern Italy to San Jose, Mario knew the Santa Clara Valley, "the Valley of Heart's Delight," when orchards bloomed everywhere. Mario passed away in 2005 at the age of 89. (Courtesy Sally Traverso.)

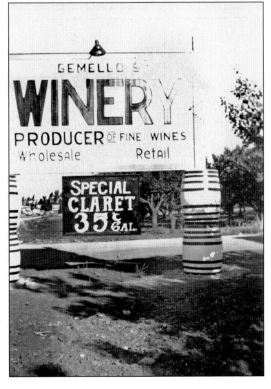

It's hard to believe that a quality wine like Gemello's special claret once sold for 35¢ per gallon. Mario would buy grapes grown at vineyards in Los Altos, Saratoga, and Campbell and, at one point, was producing up to 20,000 cases of wine per year. Gemello was famous for his *bagna cauda* parties, which featured garlic, anchovies, butter, and lots of laughter. (Courtesy Sally Traverso.)

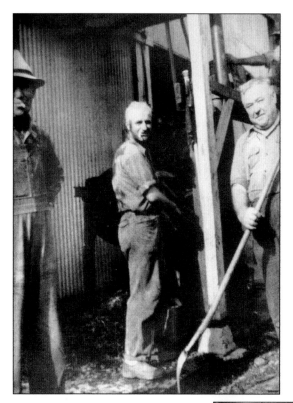

From left to right, Augusto Sibille, James Bria, and Emilio Guglielmo are seen at the Guglielmo winery in 1943. In 1925, right in the middle of Prohibition, Emilio established his winery in Morgan Hill with his wife, Emilia, and began selling to restaurants in San Francisco's North Beach Italian neighborhood, where his reputation for quality wines quickly grew. (Courtesy Gene Guglielmo.)

Closely monitoring acid and sugar levels in huge steel tanks is George Guglielmo, representing the third generation of Guglielmo winemakers in the Santa Clara Valley. With land values having risen so high, the temptation for family-owned wineries to sell has changed the landscape of the Santa Clara Valley forever. The Guglielmo winery is a reminder of the valley's special Italian agricultural past. (Courtesy Gene Guglielmo.)

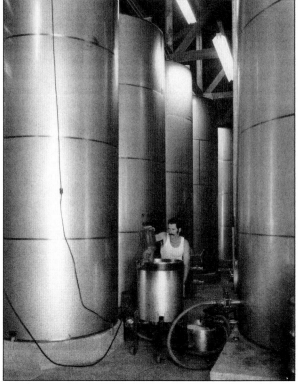

Three

FRUITS OF THEIR LABOR

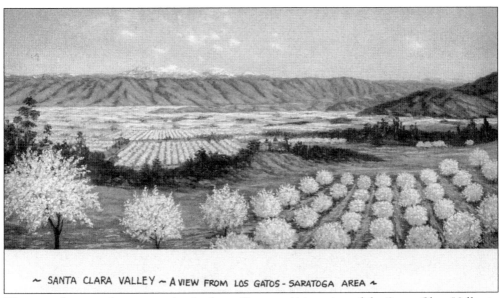

~ SANTA CLARA VALLEY ~ A VIEW FROM LOS GATOS - SARATOGA AREA ~

This reproduction of a painting by Anthony Quartuccio is a view of the Santa Clara Valley in springtime from the vantage of the Los Gatos–Saratoga area. It was probably created sometime in the late 1940s or early 1950s. In his self-published book *Santa Clara Valley, California: An Artist's View—Today and Yesterday*, Quartuccio described the garden valley as "a lush land of fruits and flowers." (Courtesy Anthony Quartuccio Sr.)

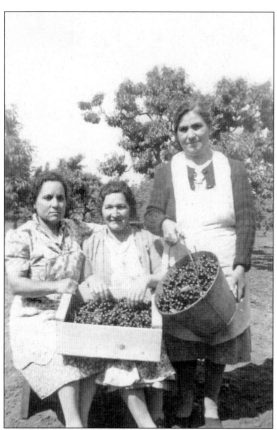

Italian women worked as hard as anyone, and not just in the kitchen. With cherry trees in the background, the women of the Quartuccio family of San Jose team up to collect cherries by the bucket. There were many others like them who made their living from harvesting the bounty of the land. Close ties and teamwork were a hallmark of the Italian community. (Courtesy Anthony Quartuccio Sr.)

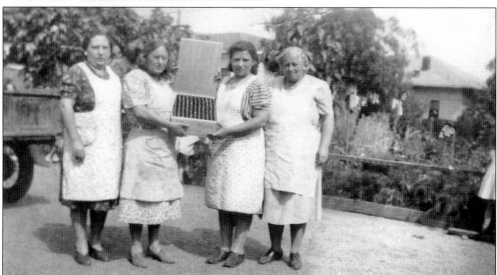

Packing cherries in boxes in 1941 required a certain method of arranging them at the bottom of the box so that when the box was flipped over, the cherries would appear in a desired pattern of presentation. From left to right are Mary Cancilla, Rose Cortese, Ann Ventimiglia, and Josephine Cancilla. This photograph was probably taken at Rose Cortese's orchard on San Felipe Road. (Courtesy Mae Ferraro.)

Josephine Barbaccia (left) is seen here inspecting one of her family's cherry trees at the Dry Creek Road ranch in 1945. She was a matriarch of the Greco and Barbaccia families, owners of the Greco Canning Company and the Santa Clara Valley Packing Company. Members of the Barbaccia family continue their contribution to the development of the Santa Clara Valley. (Courtesy Lou Barbaccia.)

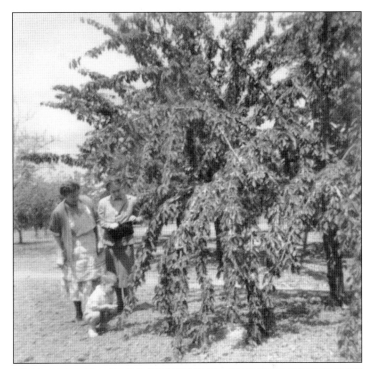

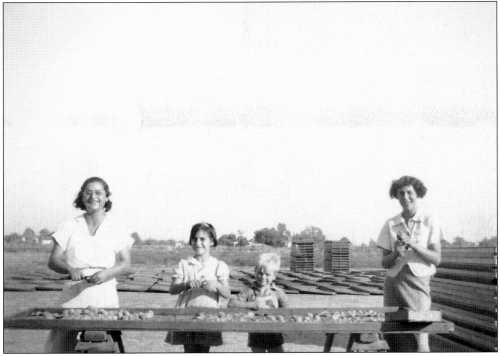

Cutting apricots in 1937 on the Chimenti ranch at 1720 Alum Rock Avenue are, from left to right, Lea ?, Lucille Chimenti, unidentified, and Ann Vicari. After the apricots were pitted, they would be laid out to dry in the sun for several days on the large trays. The Chimentis had three acres of apricot and prune orchards. (Courtesy Lucille Basso.)

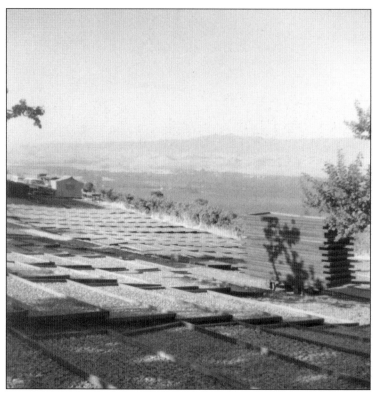

This is the view from Joe Quartuccio's 18-acre Chaboya Road ranch in the Evergreen district of East San Jose in 1969. Apricots were popular and plentiful around the valley, as evidenced by the rows of drying trays. The panorama of the entire valley was breathtaking. By 1980, the property had been sold for development. (Courtesy Anthony Quartuccio Sr.)

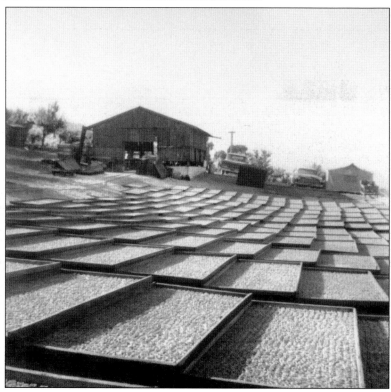

At the same time Joe Quartuccio, also known as "Shorty" Joe, was drying trays of apricots on the last remaining parcel of the Chaboya land grant, he was also thrilling audiences with his style of country swing music and helping mankind take one giant leap by training the astronauts at the NASA Ames Research Center for their lunar landing in 1969. (Courtesy Anthony Quartuccio Sr.)

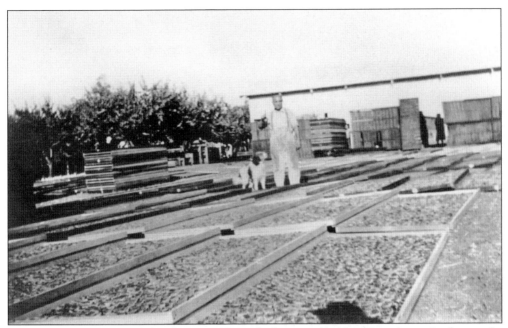

John Gemello is seen with his dog in 1930 overlooking stacks of apricots drying in the sun. In order to avoid the disaster of Prohibition, Gemello started growing apricots and other fruits and vegetables. It was said that Prohibition and revenue agents were more responsible for the passing of small family wineries than was competition from larger corporate wineries. (Courtesy Sally Traverso.)

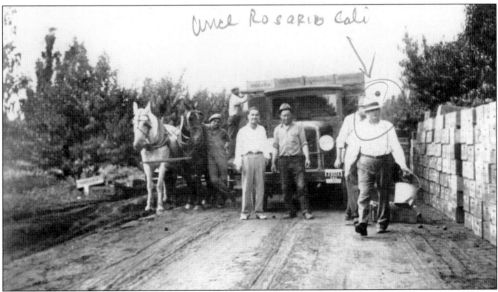

The Cali brothers of Cupertino started with a single truck, hauling fruit from their own orchards and others to the Shukl Canning Company in 1924. The stacks of boxes read Shukl and Company. The horse team on the left is symbolic of the way things once were. Technology was rapidly changing the valley's landscape. The orchards in the background would soon fade from view in the years ahead. (Courtesy Ron Cali.)

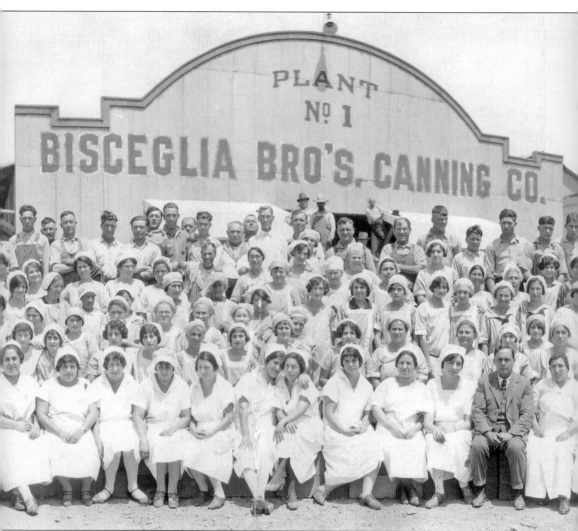

The Bisceglia Brothers Canning Company was located on South First Street near "Goosetown," the Italian settlement that encompassed a section bounded by Alma Street on the south, Auzerais Street on the north, First Street on the east, and the Guadalupe River on the west. Many of the workers in this photograph were Italian immigrant women. In 1917, women cannery workers formed a union called the Toilers of the World. Low wages, long hours, and nonrecognition of their union were the major complaints of the day. (Courtesy Buzz Erena.)

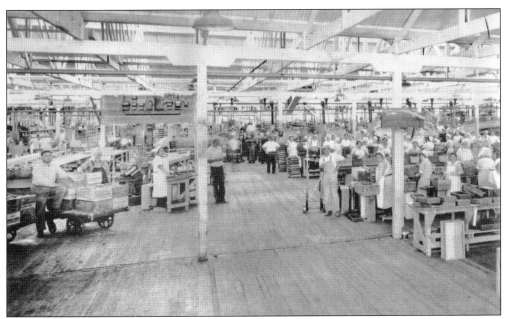

The Bisceglia brothers frequently used names from their native Italy to brand their canned products, such as their Arno-brand sliced yellow cling peaches. The Arno is a river in Tuscany. The Bisceglias came to the United States in 1885 and set up their cannery in Morgan Hill in 1903. Italian labor was, by this time, crucial to running the canneries in Santa Clara. (Courtesy Gary Rovai.)

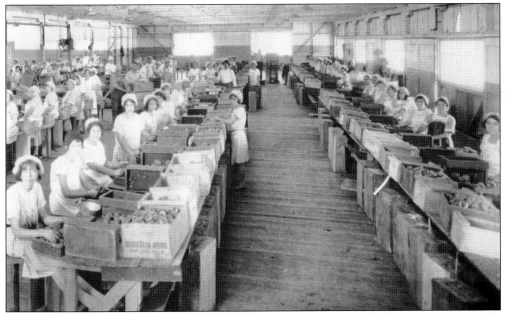

Italian immigrant women are pictured at their stations inside the Bisceglia Brothers Cannery. The four Bisceglia brothers were Joseph, Alfonse, Bruno, and Pasquale. Joseph was the president of the company. In 1913, the brothers moved their cannery to Monterey Road in San Jose. By 1919, the Bisceglia Brothers Canning Company was the largest cannery in the world and employed 1,000 workers. (Courtesy Gary Rovai.)

Every member of the first elected board of directors of the Santa Clara County Fruit and Berry Growers' Association, which was established in 1932, was Italian. The wholesale produce market, known as the Grower's Market, was located at Seventh and Taylor Streets. From left to right are Silvio De Mattei, Archimede Antichi, Nazareno Tassi, Joe Marianelli, and Joe Monferino. (Courtesy Monte Antichi.)

This is a front view of the Gemello vegetable truck in 1925. Son Mario and daughter Sally take a picture with their father. Although it's not very clear, John Gemello is holding what looks to be a handheld scale for weighing fruits and vegetables. (Courtesy Sally Traverso.)

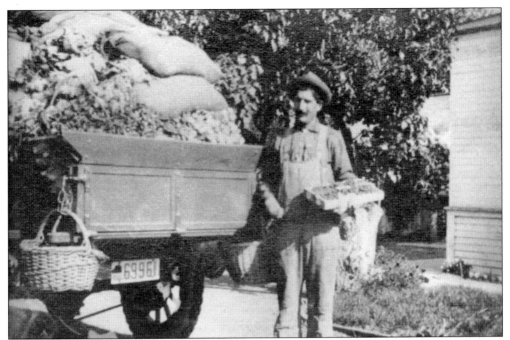

John Salamida, whose family is on the front cover of this book, stands with what looks to be a carton of strawberries in 1926. With his truck packed high with fruits and vegetables grown by other farmers, Salamida had an assigned route that included Alviso, Santa Clara, and Willow Glen. (Courtesy John Salamida Sr.)

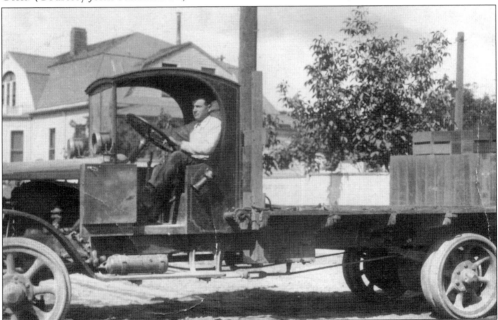

In the 1920s, Sal Guido would drive his truck packed with tons of tomatoes from the San Joaquin Valley via the Altamont Pass. Steep hills and slow speeds around Altamont made it easier for some people to run alongside the truck and pilfer vegetables. It soon became necessary to have a "swamper" sit on the back and keep guard. (Courtesy Gene Guido.)

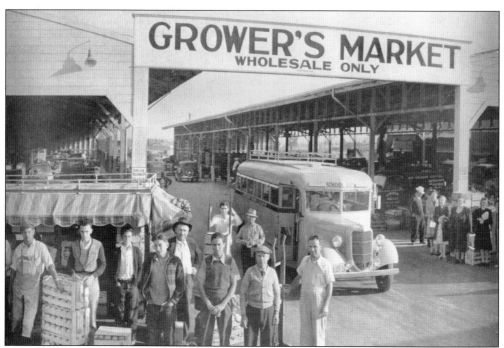

Starting in 1932, the Grower's Market at Seventh and Taylor Streets in San Jose was the main destination for the valley's vegetable and fruit farmers to sell their produce wholesale. In 1981, the Amerian brothers bought the wholesale market and renamed it the San Jose Produce Terminal. (Courtesy Adolph and Esther De Mattei.)

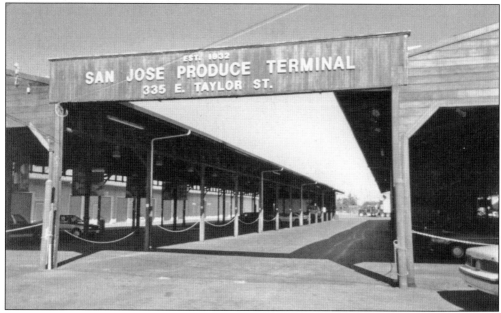

This is what the Grower's Market looked like many years after it had been founded by the original Italian board of directors. By the end of the 1980s, the market was sold. Right next to the market was Bini's, which served breakfast and lunch to the cannery employees who worked nearby. (Courtesy Edith Bini Williams.)

Cyril Barbaccia holds a bucketful of prickly pear cactus or "figidini" at the 50-acre Barbaccia ranch on Dry Creek Road. Next to Cyril is his brother Lou, who later grew up and spent 10 years with the Military Police unit of the 49th Division of the California National Guard. Standing third from left in the back row is Josephine Barbaccia. (Courtesy Lou Barbaccia.)

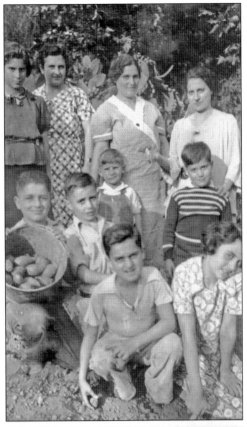

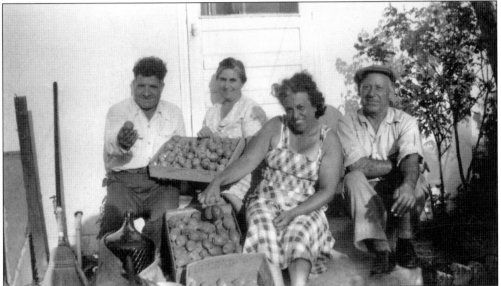

The Quartuccios show off their prized figidini in 1951. Prickly pear cactus were called "figidini" in Italian because they were considered "figs of India." Many Italian families truly considered themselves blessed to have experienced the magic of the early days of the Valley of Heart's Delight. (Courtesy Anthony Quartuccio Sr.)

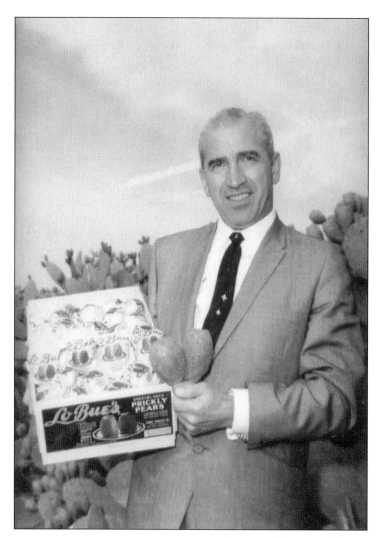

Victor J. LoBue is pictured here in a 1965 promotional advertisement for his company's special-pack prickly pears. Mariano LoBue, Victor's uncle, helped start the San Jose Canning Company in 1919. The company shipped much of their product to the East Coast, especially during the holidays. The LoBue family, early settlers to the Santa Clara Valley, contributed much to the economic development of the area. (Courtesy Vic LoBue.)

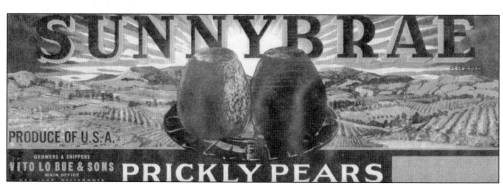

The Sunnybrae label designated a level of quality just below the Patricia brand, which was reserved for LoBue's premium-pack green beans. Sunnybrae-brand prickly pears were popular in the 1930s. (Courtesy Vic LoBue.)

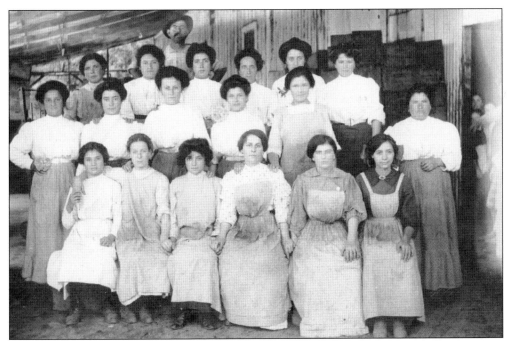

This photograph was taken around 1917 at the Filice and Perrelli cannery in Gilroy. The man standing at the top is Michele Filice, whose son Gennaro started the cannery with his partners. From left to right are (first row) Clara La Macchia, Mary Filice, Adelade Abbruzzina Scalonina, Liz Piemontell, Fanny Piemontell, and unidentified; (second row) Filomena Filice, Angelina Perrelli, Filomena Cala, Conchetta La Macchia, Ang Buccero, and Teresa La Macchia; (third row) Jenny Chiado, Pasqualina La Macchi, Clara Filice, Angelina Marrazzo, Angelina Mondelli, and Mary Olivero. (Courtesy Bunny Filice.)

The Bisceglia brothers first started the old Filice and Perrelli cannery at Lewis and Railroad Streets in Gilroy. Like the Bisceglia brothers, both the Filice and Perrelli families originated from Calabria, Italy. After a fire destroyed the original cannery in 1913, Gennaro Filice, his brother Ralph, and his brother-in-law Pasquale decided that they would take over from the Bisceglias and rebuild the cannery on Lewis Street. (Courtesy Gilroy Historical Museum.)

These women cannery workers from Gilroy are, from left to right, Marion Filice Cimino, Marion Poli, unidentified, Margaret Filice, and unidentified (seated). They probably worked for the Bisceglia Brothers Cannery, which was destroyed by fire in 1913. With help from A. P. Giannini's Bank of Italy, Gennaro Filice and his partners took over operations from the Bisceglias and rebuilt the cannery in 1914. (Courtesy Bunny Filice.)

Some of the women workers gather in 1940 for a luncheon at the TriValley Cannery, one of many canneries on Taylor Street. The women pictured here include Ann Lazarra, Rickie Cincirulo, Rose Arena, Mary Cancilla, May Germano, Lina Catanzaro, and Rose Cantania. By the time World War II had started, fewer Italian immigrant women were working in canneries. (Courtesy Mae Ferraro.)

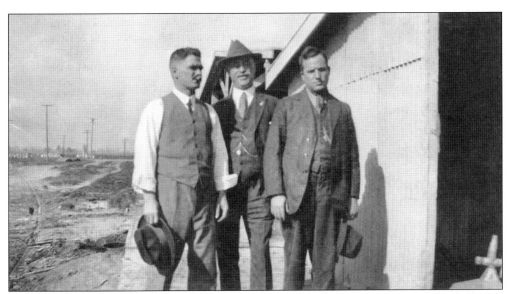

Victor Greco (left) of the Greco Canning Company, pictured here in 1924, was the grandfather of Lou Barbaccia, whose mother was Josephine Greco Barbaccia. In 1913, Victor Greco organized the Greco Canning Company and opened a cannery at Howard and Autumn Streets in San Jose. During World War I, Greco was the largest packer of tomatoes in the world. The Greco Canning Company ceased operations in 1938. (Courtesy Lou Barbaccia.)

Philip Ciro Barbaccia came to San Jose from Sicily in 1907 and worked eight years for the California Packing Corporation, later known as Calpak. In 1920, Philip Barbaccia and his younger brother Nicholas founded the Santa Clara Valley Canning Company with the help of local investors. Philip served as vice president. Today Philip's son, Lou Barbaccia, is a successful businessman and real estate developer. (Courtesy Lou Barbaccia.)

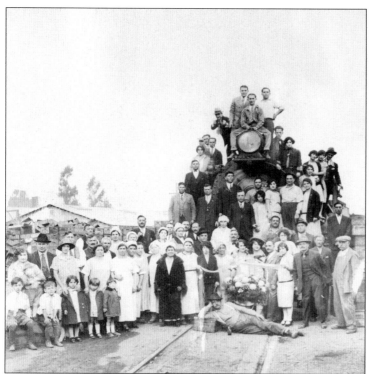

Before the Santa Clara Valley became the high-tech mecca known as "Silicon Valley," the canneries were the main engine of economic growth and prosperity. They were at the crossroads of agriculture and industrialization. The Italians were very much like the underlying steam engine in this photograph, taken at the Hershl cannery in San Jose. They were an economic force that helped bring prosperity to the valley. (Courtesy Marge Chiechi.)

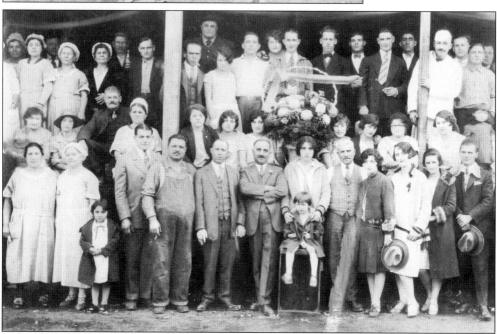

These Italian men, women, and children are the same people seen in the previous photograph. The occasion was the yearly cannery picnic, which usually took place near the end of the canning season in September or October. Some are wearing work clothes while others have on their Sunday best. The cannery was a family affair for the Italians. They enjoyed themselves and took great pride in their work. (Courtesy Marge Chiechi.)

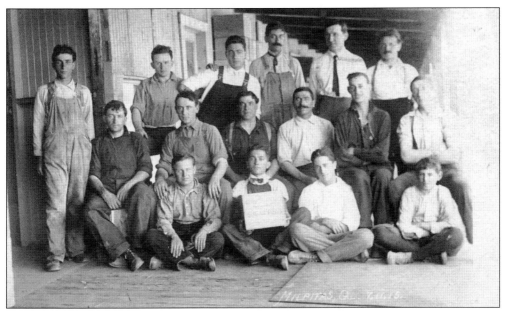

Philip Barbaccia (possibly second from left standing in back) takes a moment for a group photograph on July 11, 1915, in Milpitas. It is not clear which group this is, but it would seem to be one of the companies that merged in 1916 with three other canning operations to become known as the California Packing Corporation. Philip formed his own company in 1920. (Courtesy Lou Barbaccia.)

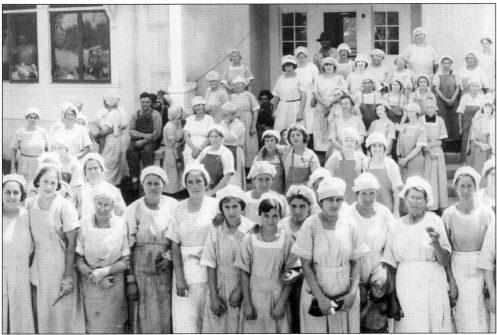

Based in Sacramento, the Virden Packing Company also operated in San Jose, although the exact location is not known. San Jose, the first state capitol of California, was home to many canneries and a growing Italian immigrant population needed to drive expansion and valley prosperity. Many of the cannery workers in 1910 were Italian women. (Courtesy Buzz Erena.)

Nick Chiechi and his sister Grace are seen here in the rail yard of the Hershl cannery sometime in the late 1920s. Since the canneries were so central to the livelihood of many in the Italian community, most people lived within a mile of work. Almost everyone walked or rode a bike for transportation. (Courtesy Marge Chiechi.)

In springtime, picking mustard greens was a favorite ritual of many Italian families. Items favored by the Italians such as garlic, mustard greens, and dandelion root are tasty and healthy. A glass of wine and mustard greens lovingly prepared in tomato sauce is no doubt the inspiration for the saying "*Salute per cent'anni,*" which means "Good health for 100 years." (Courtesy Marge Chiechi.)

The early Italians to the Santa Clara Valley loved growing fruits and vegetables. The "Eden of the World," a phrase used to describe the valley, provided a way of life that sustained both body and soul. Here Joe Quartuccio is dwarfed by a giant beanstalk at his North Sixteenth Street home in San Jose. (Courtesy Anthony Quartuccio Sr.)

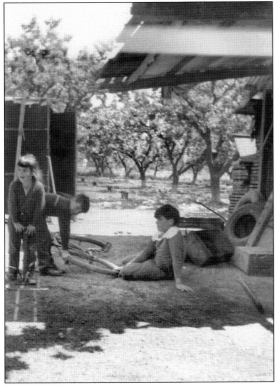

Seen here in 1956 amid the idyllic days of spring in the Valley of Heart's Delight is Margie Chiechi on her family's ranch. With the birds chirping and the orchards in blossom, there could be no better place for a child to grow up. Happiness and laughter were in much abundance around the Chiechi family. (Courtesy Marge Chiechi.)

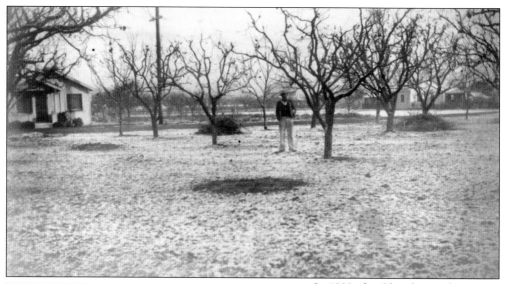

In 1932, the Chiechi ranch in San Jose saw temperatures dip low enough to leave a light dusting of snow. While fruit trees need to have a certain number of chill hours during the dormancy period in order to produce healthy fruit in the spring, it was always a concern to the Italian farming community if temperatures dropped too low. (Courtesy Marge Chiechi.)

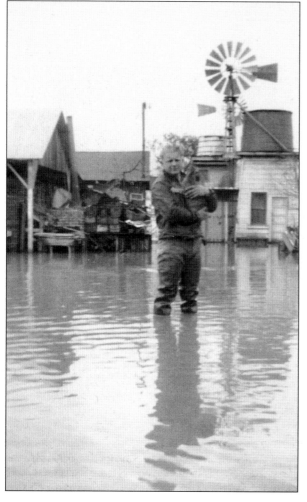

In 1937, the Basso ranch experienced some flooding, as did the rest of San Jose. But where there was a negative, the Italians usually found a positive. Those who had small rowboats charged a fee to ferry people from point to point. When times were tough, they kept a smile on their faces and helped their neighbors get by. (Courtesy Lucille Basso.)

Four

FAMILY AND FRATERNITY

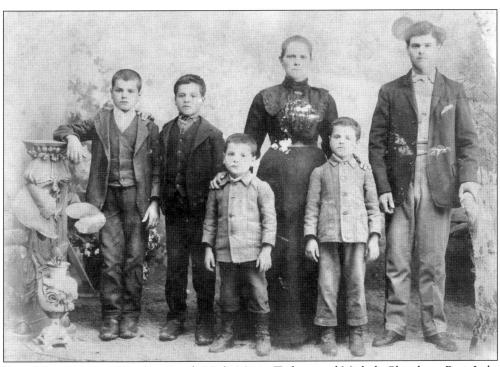

From left to right are Winslow, Frank, Nick, Maria, Trifone, and Michele Chiechi in Bari, Italy. The Chiechis moved to San Jose and settled at 820 Northrup Avenue in 1911. Nicola (Nick) Chiechi became an orchardist, growing apricots, pears, and cherries, among other fruits. Trifone is named after San Trifone, the patron saint of Adelphia, which is just outside of the city of Bari. (Courtesy Marge Chiechi.)

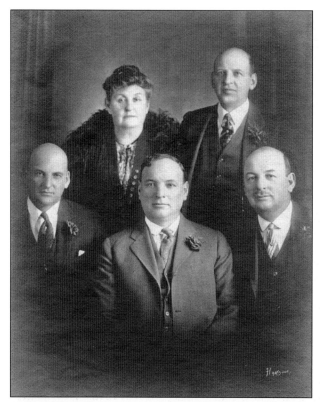

The second generation of the pioneer Picchetti family of Cupertino poses for a photograph with their mother, Teresa. Her sons are, from left to right, (seated) Attilio, John, and Antone; (standing) Hector. John and Antone took over the winery from their father, Vincenso, and uncle, Secondo. Hector worked with his brother Attilio, who owned the Plaza Garage, which was located at South Market Street in San Jose. (Courtesy Hector Picchetti.)

This partial shot of Marie DePalma Volp's extended family was taken around 1912 in front of the Barbaccia home on Bird Avenue in San Jose. Family members in this photograph had surnames such as Barbaccia, Naso, DePalma, Bellomo, Russo, Giacolone, and Della Maggiora. (Courtesy Marie Volp.)

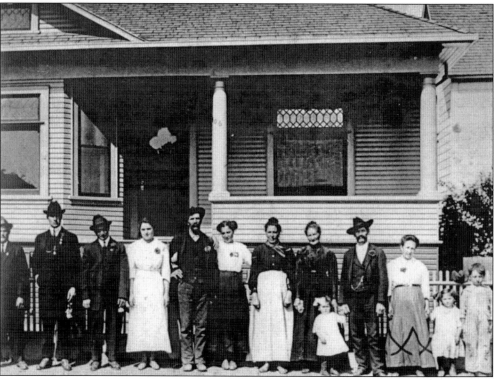

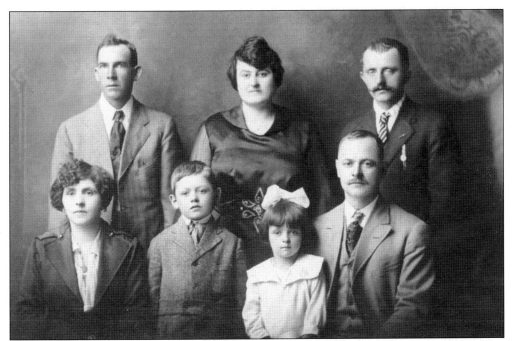

Members of the Bonino and Bisio families are pictured together before coming to San Martin from Bingham, Utah, in 1914. Standing at far right is Luigi Bonino, who had a very dangerous job inside the Bingham mines that required him to grease the network of pulleys that moved the ore to the surface. The boy standing in front is Tony Bonino, and next to him is his mother. (Courtesy Louis Bonino.)

Many Italians worked in the now-defunct mining town of Homeboy in Bingham, Utah. Thousands of Italian immigrants went to work in the mines and suffered in squalid conditions. The Boninos were able to come to the Santa Clara Valley around 1914 and start new lives as farmers. (Courtesy Louis Bonino.)

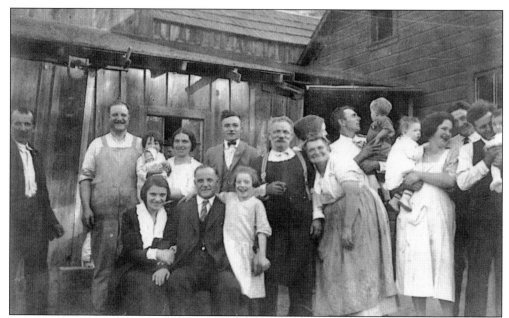

Carlo and Maria Panighetti, in the middle, stand with other members of the pioneer Panighetti family during a wedding celebration at their farm in the Santa Cruz Mountains in 1921. The mood is clearly one of happiness. Carlo Panighetti was born in the province of Novara, Italy, in 1856. He married Maria Perone in 1883 and came to the Santa Clara Valley in 1885. (Courtesy Paula Quinterno.)

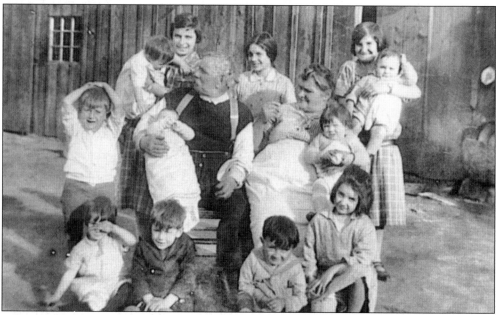

After working on local farms, orchards, and vineyards, Carlo Panighetti was able to purchase 80 acres of land on which he started making improvements. One can understand that the reason they had 11 children was to help with maintaining the homestead. Some of the names of Carlo's grandchildren and their friends in this 1927 photograph are Catherine Scilini, Linda Pianto, Teresa Scilini, Madeline Pianto, and Charles Gagliasso. (Courtesy Paula Quinterno.)

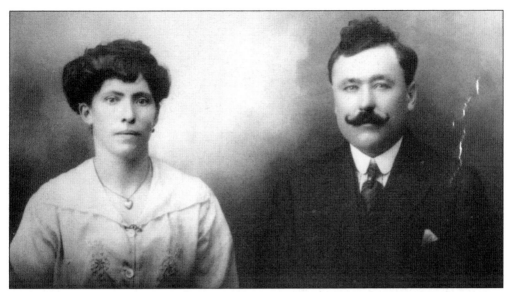

Emilio Guglielmo and his wife, Emilia, founded their winery in 1925 in Morgan Hill. Emilio was born in 1883 in the Piedmont region in northern Italy. After he came to America at age 25, he worked as a carriage driver for Frank's Tannery in Redwood City. Like many Italian men, Emilio returned to Italy to bring back his bride once he had established himself. (Courtesy Gene Guglielmo.)

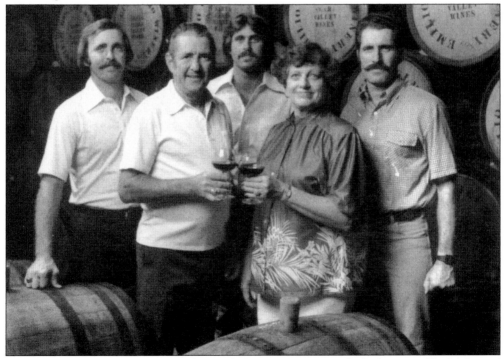

The second and third generations of the Guglielmo family carry on the legacy started by Emilio and Emilia. In the late 1940s, Emilio's son George took over the operations of the winery. Standing in front are George and his wife, Madeline. From left to right, sons Gene, Gary, and George, the third generation, continue the family tradition in the wine business. (Courtesy Gene Guglielmo.)

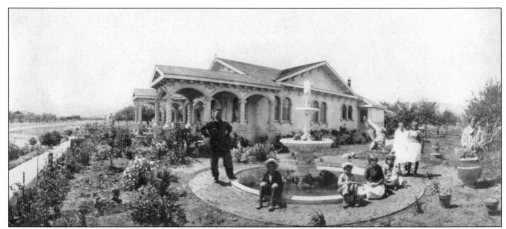

In 1922, Federico Quinterno (far left) and his wife, Francesca (far right), stand with their family at their home on Pasadena Avenue in Monta Vista, which is part of Cupertino. Federico, an excellent stonemason, sculptor, and artist, worked briefly on the Palace of Fine Arts building, part of the Panama-Pacific Exposition held in San Francisco in 1914. (Courtesy Paula Quinterno.)

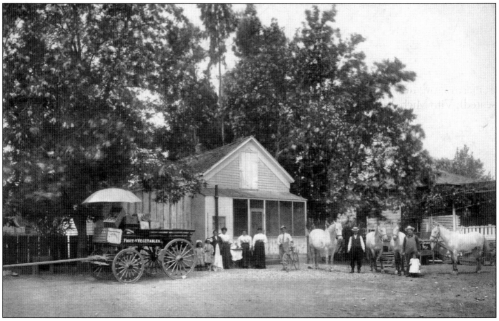

This wide-shot photograph of the Salamida family's home at 542 North Fifth Street was taken sometime around 1914. Standing with his son Joseph (far right), John Salamida sold fruits and vegetables from a horse-drawn cart. The cart and horses were the means by which the family made its living. By the mid-1920s, John Salamida would sell his produce from the back of a truck. (Courtesy John Salamida Sr.)

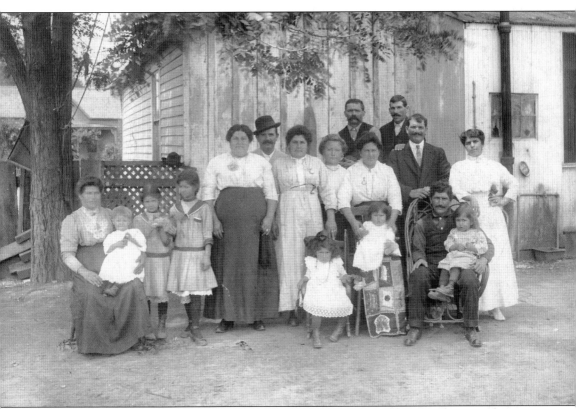

This is the complete photograph of the Salamida family that appears on the cover of this book. Pictured here are, from left to right, (first row) Rosa Maggi Salameda with her son Joseph, first cousin to the contributor of this photograph, John Salamida Sr.; two unidentified girls (the tallest girl was the last person in this photograph to recently pass away); Grace Tomasino; Francesco Tomasino; two unidentified women; Alvira Salamida with her children Nicolas and Mary (both seated); Vito Michele Maggi; Elisabetta Maggi; and John Salamida with his son Joseph V. on his lap; (second row) Vince Ginestra and Angelo Lello. Note that Rosa's family spelled their surname with an "e" instead of with an "i." (Courtesy John Salamida Sr.)

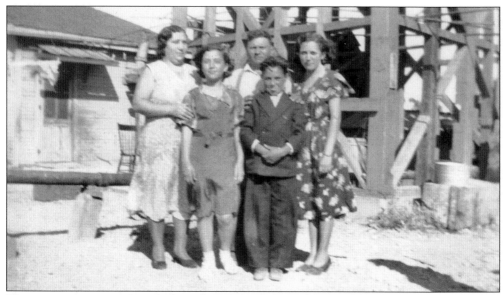

The pretty woman standing on the right is Mae Ferraro, who over the years has been recognized as a humanitarian of the highest order. Mae is pictured here with her family in 1935 on their four-acre farm on North Eleventh Street. From left to right are Mary Sunseri Cancilla, Anne Cancilla Nibbi, Joe "Chickie" Cancilla, and Luis Cancilla. (Courtesy Mae Ferraro.)

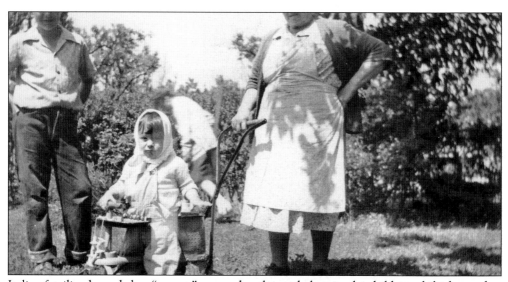

Italian families depended on "nonna," or grandmother, to help raise the children while the mother and father went out to work. Many of the Italians who grew up in the days of the Valley of Heart's Delight all seem to agree that life was better then. Children reigned supreme, and the family was the center of gravity in the Santa Clara Valley. (Courtesy Marge Chiechi.)

The Italian farmer and winemaker John Gemello is seen here with his family in 1925, surrounded by rows of vegetables and tranquility at what later became the Mayfield Mall site in Mountain View. Like the Gemellos, many families grew up on the rich fertile soil of the Santa Clara Valley. All aspects of this photograph are now but a distant and faded memory. (Courtesy Sally Traverso.)

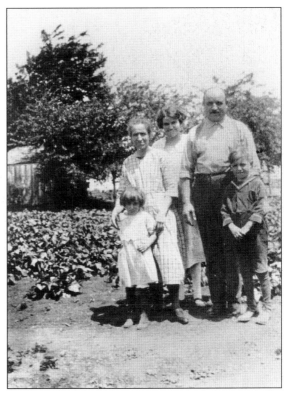

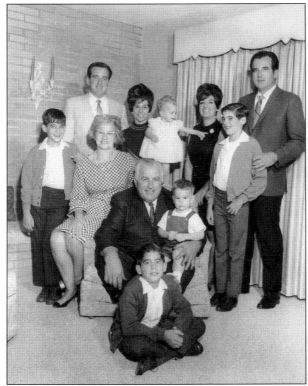

Family patriarch Sam Della Maggiore (seated) is seen here in 1968 with his sons Gene and Dario and their wives and children. Sitting behind Sam is his wife, Aldina, who became his bride in 1934. A former chairman of the Santa Clara County Board of Supervisors, Sam was a great family man and brought that spirit with him to the community that he served. (Courtesy Gene Della Maggiore.)

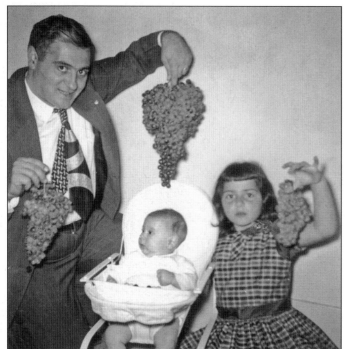

Considered the "Father of Soccer" in Santa Clara County, Umberto Abronzino is pictured here with his daughter Linda and son Aldo in 1955 when the total population of San Jose was about 92,000. Umberto came from Italy in 1953 and ran a barbershop from his home. His dedication to the sport of soccer and to the youth of Santa Clara County has been immeasurable. (Courtesy Linda Abronzino.)

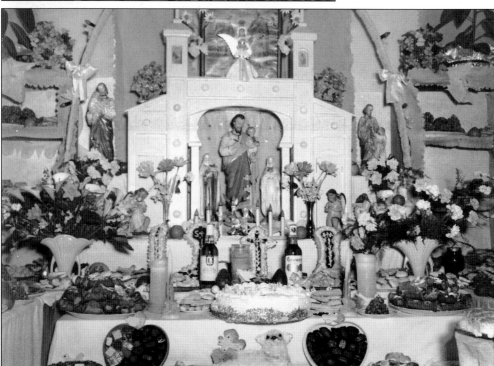

The St. Joseph's Day table is celebrated on March 19 in honor of St. Joseph, who was said to have saved the people of Sicily from droughts during the Middle Ages. The feast involves an elaborate presentation of many different foods that are dedicated on an altar to St. Joseph. This photograph is believed to have been taken at the home of Vito Randazzo in 1940. (Courtesy Lucille Basso.)

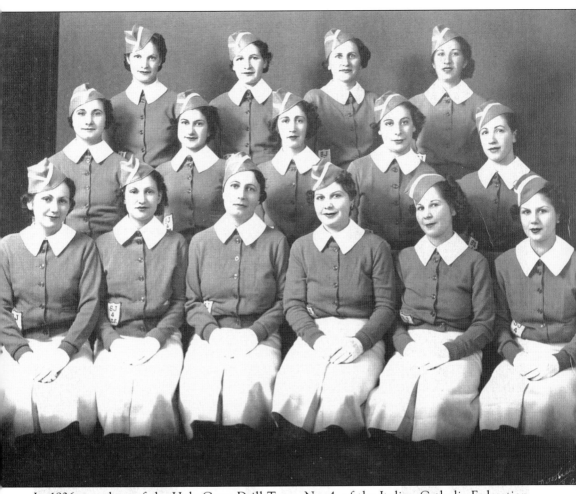

In 1936, members of the Holy Cross Drill Team, No. 4, of the Italian Catholic Federation participated in competitions and marched in parades. At the time of this photograph, they were planning to participate in inaugural festivities as well as assist with a charity ball. From left to right are (first row) Mary Cancilla, Irene Catanzaro, Louise Chiappino (team captain), Josephine Campagna, Caroline Campagna, and Marietta Campagna; (second row) Mary Gallo, Florence Gurgiolo, Patrina Burriesci, Frances Gullo, and Catherine Ferraro; (third row) Mary Spinetti, Margaret Nickoletti, Margaret Castoro, and Carmela Cuffaro. Marietta Campagna's family owned the Sicilia Macaroni Company. (Courtesy Marietta Sunseri.)

This mural of Christ ascending to heaven was painted by Anthony Quartuccio, who grew up in the Northside neighborhood where Holy Cross Church is located. Holy Cross, founded in 1906 to serve the Italian community, was originally called SS Sagradischimo Crucifisci, which is Latin for "Most Holy Crucified or Most Holy Crucified One." Holy Cross became the official name in 1927. (Courtesy Anthony Quartuccio Sr.)

Edith, Dominic (center), and Ernest Rosati are seen here during their First Communion in 1921. Edith Rosati would later grow up to marry Abe Bini and become the future owner of Bini's restaurant, which was a popular breakfast and lunch spot that served the cannery workers around Taylor and Seventh Streets. One of Edith's brothers would later run the O'Connor Pharmacy. (Courtesy Edith Bini Williams.)

Hector (left) and Virgil Picchetti are seen here on the day of their First Communion. Their father was Anton Picchetti, and their grandfather was pioneer Vincenso Picchetti, who came from the province of Novara, Italy, in 1875 to settle on Montebello in what is now Cupertino. Virgil would make the ultimate sacrifice by giving his life for his country during the Second World War. (Courtesy Hector Picchetti.)

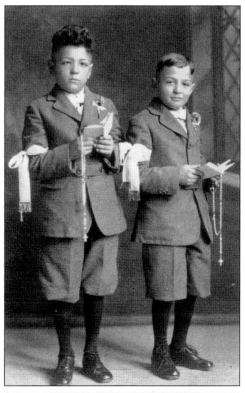

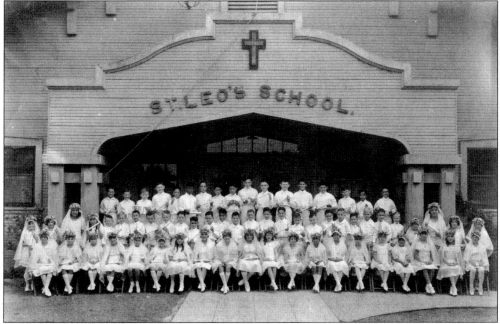

St. Leo the Great School, first operated under the Sisters of Notre Dame de Namur in the early 1900s, is named after Pope Leo I, who was born in 400 AD in Tuscany, Italy. St. Leo the Great parish is one of the oldest in the San Jose Diocese. This photograph of children on their confirmation day was taken in 1939. (Courtesy Lou Barbaccia.)

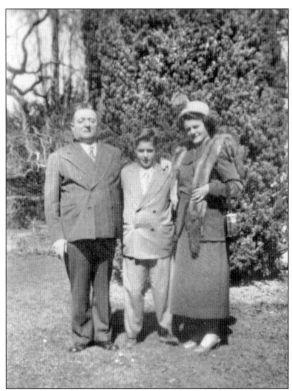

John and Ann Sobrato pose for a picture with their only son, John Albert, who attended the Palo Alto Military Academy before going to Santa Clara University. Ann Sobrato High School is set on 120 acres that was donated by the Sobrato family to the city of Morgan Hill in memory of Ann, who passed away in 2000. (Courtesy John A. Sobrato.)

The brothers Ferrari and their sister were originally from Aulla, Italy. From left to right are (seated) Ray, Larry, Roy, and Fern; (standing) Bruno. The family eventually settled in the Bay Area and started growing and selling fruits and vegetables. Ray Ferrari and his brothers then started a construction demolition company called Ferma Corporation, which is based in Mountain View. Ferma has been involved in some of the biggest demolition projects on the West Coast. (Courtesy Ray Ferrari.)

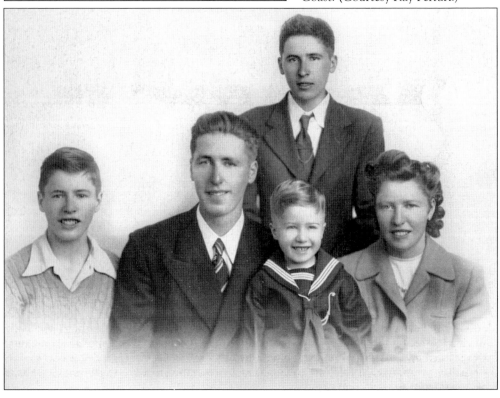

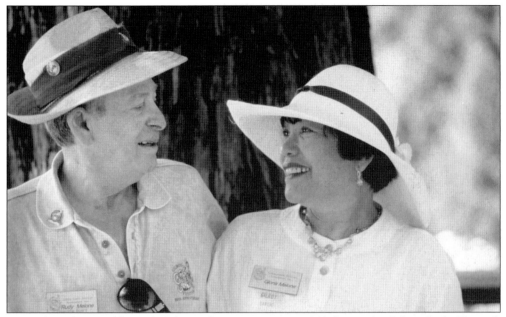

Dr. Rudy Melone and his wife, Gloria, share a moment in 1998 during the Gilroy Garlic Festival, which they founded in 1979. After Dr. Melone passed away in 1998, the Dr. Rudy Melone Memorial Scholarship was created to honor outstanding students in academic achievement and community service and to nurture future leaders of the Garlic Festival Association. (Courtesy Dr. Gloria Melone.)

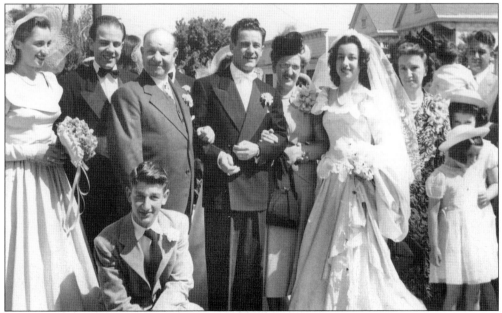

Mario Mastrocola and his bride, Marjorie Margiotta, are seen here in 1948 at the Holy Family Church. Holy Family was another church built especially to serve the growing Italian community. It was located on River Street and was established in 1906 by Capt. Egidio Zeiro, who was on the building committee. In 1969, the bulldozers razed the church to make way for the Guadalupe Parkway. (Courtesy Michael Mastrocola.)

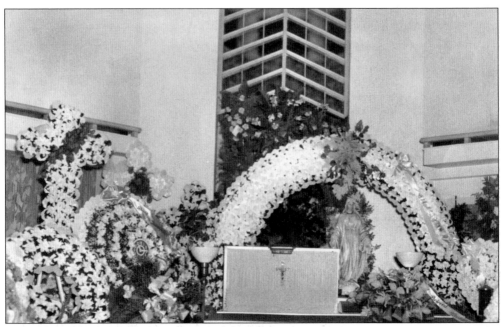

Funeral customs within the Italian community included something known as the "stopped clock," which was meant to represent the time of death. Other floral arrangements include the "gates of heaven" and the "half moon with star." In this photograph, there is an actual clock nestled in a floral arrangement to represent the "stopped clock." This photograph was taken at Gimelli's floral shop in 1940. (Courtesy Gene Gimelli.)

Francesca Vicari Chimenti made her Declaration of Intention for permanent residence in 1942. World War II was a period of intense scrutiny and uncertainty for the Italians, especially those living on the West Coast. In November 2000, the Wartime Violation of Italian American Civil Liberties Act, officially known as Public Law 106-451, was signed into law. The mistreatment of the Italian community was officially acknowledged. (Courtesy Lucille Basso.)

Five

PRIDE AND PROGRESS

Born March 30, 1882, in San Francisco, Dismo Mario Denegri grew up to become a pharmacist. In 1910, he was elected to represent the 45th district of San Francisco in the California State Assembly. In 1914, he moved to San Jose and was elected to the San Jose City Council in 1920, serving for 12 years. During his tenure in the California State Assembly, Denegri was responsible for the designation of Columbus Day as a legal holiday in California. Considered the most able civic leader that the local Italian American community has ever had, Denegri was also the chief organizer of the Loyal Italo-American Club in 1919, which later became the Civic Club. He died in 1932. (Courtesy David G. Ferrari.)

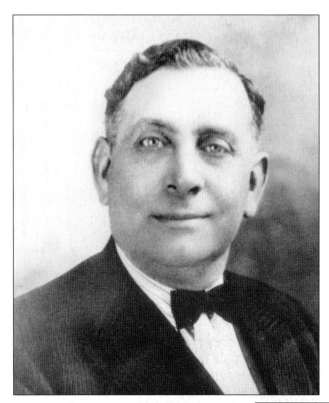

James (Giacomo) Princevalle was born in Gilroy on September 1, 1876. He joined the family grocery business after graduating in 1896 from the Garden City Business College in San Jose. He was elected to the Gilroy City Council in 1904 and served until 1910. In 1920, Princevalle was elected the 18th mayor of Gilroy and served six terms until he retired in 1932. He died in 1936. (Courtesy Gilroy Historical Museum.)

Gennaro Filice arrived in Gilroy from Cosenza, Italy, via Canada in 1907. He began working for the Bisceglia Brothers Cannery in Hollister before setting up his own cannery in 1918 with partner John Perrelli. The Filice and Perrelli Corporation once employed 1,300 workers and included 50 varieties of canned products. Gennaro was an innovator in the development of modern canning methods and machinery, notably the Filper Pitter for pitting cling peaches. (Courtesy Gilroy Historical Museum.)

While Dr. Rudy Melone seems to be best known as the founder of the Gilroy Garlic Festival, he was in fact an extraordinary educator and served as president of Gavilan Community College in Gilroy for eight years. He received many awards throughout his career for his accomplishments in the field of education. Dr. Rudy Melone believed that the community college was the quintessential American institution because of its equal-opportunity proposition. (Courtesy Dr. Gloria Melone.)

Voted by *Time* magazine as one of the 100 most influential people of the 20th century, Amadeo Peter (A. P.) Giannini (right) was an innovator who understood that it was the "little guy" who needed access to modern banking services in order to grow the economy. Sitting next to Giannini in 1948 is his son Laurence Mario, who was affectionately called "L. M." A. P. Giannini died the following year. (Courtesy Virginia Hammerness.)

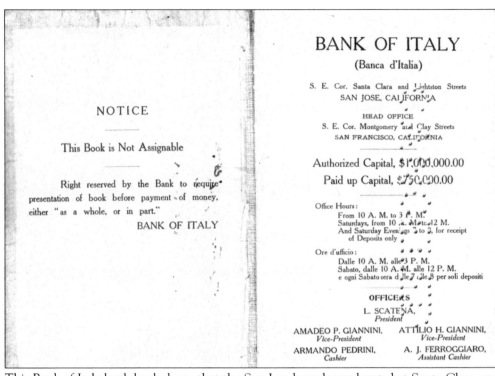

BANK OF ITALY

(Banca d'Italia)

S. E. Cor. Santa Clara and Lightston Streets
SAN JOSE, CALIFORNIA

HEAD OFFICE
S. E. Cor. Montgomery and Clay Streets
SAN FRANCISCO, CALIFORNIA

Authorized Capital, $1,000,000.00

Paid up Capital, $750,000.00

Office Hours:
From 10 A. M. to 3 P. M.
Saturdays, from 10 A. M. to 12 M.
And Saturday Evenings 7 to 9, for receipt
of Deposits only

Ore d'ufficio:
Dalle 10 A. M. alle 3 P. M.
Sabato, dalle 10 A. M. alle 12 P. M.
e ogni Sabato sera dalle 7 alle 9 per soli depositi

OFFICERS

L. SCATENA,
President

AMADEO P. GIANNINI, ATTILIO H. GIANNINI,
Vice-President *Vice-President*

ARMANDO PEDRINI, A. J. FERROGGIARO,
Cashier *Assistant Cashier*

NOTICE

This Book is Not Assignable

Right reserved by the Bank to require
presentation of book before payment of money,
either "as a whole, or in part."

BANK OF ITALY

This Bank of Italy bank book shows that the San Jose branch was located at Santa Clara and Lightston Streets; note that the office hours are written in both English and Italian, since many of the clients were Italian immigrants. The early president of the Bank of Italy was Lorenzo Scatena, who was A. P.'s stepfather. Lorenzo also ran a very successful fruit commission house in San Francisco. (Courtesy Virginia Hammerness.)

Here Giannini is commemorated along with other great figures in Italian history. His parents taught him deep respect for the values of tradition. The stern look on this 1973 stamp belies the fact that Giannini was a kind man who had no real interest in being rich. Having witnessed the murder of his father over a "$1 debt," Giannini knew he did not want to be controlled by money. (Courtesy Bunny Filice.)

Sam Della Maggiore grew up on North Thirteenth Street in San Jose. He was elected to the Santa Clara County Board of Supervisors in 1953 and served until 1969. He represented the second district and served as chairman of the board four times. Before going into public service, Sam was a top athlete, coach, and educator. (Courtesy Gene Della Maggiore.)

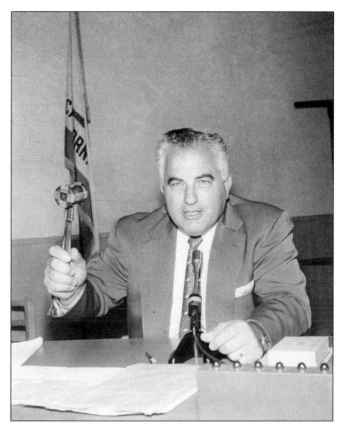

One can see that Sam Della Maggiore took his campaign very seriously. His talents as a top athlete, coach, and educator served him well in his political career representing the second district of Santa Clara County. One meaning of the name Della Maggiore in Italian is "greater." It seems that Sam's surname fit him well, as he was usually working for the greater good. (Courtesy Gene Della Maggiore.)

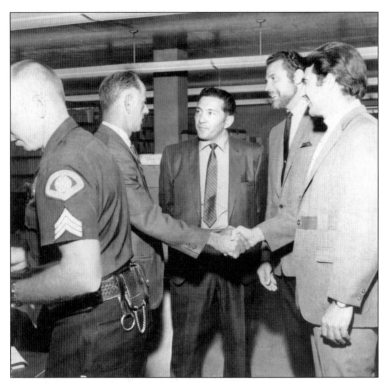

Capt. Joseph Azzarello (second from left) greets actors Paul Picerni (right) and Michael Dante, who were in town for the Celebrity All-Star Softball game to benefit the San Jose Police Activities League. Standing in the middle is Det. Jimmy Guido, the key organizer of the annual charity event. Both Azzarello and Guido were some of the first men of Italian descent to serve and protect with the San Jose Police Department. (Courtesy James J. Guido.)

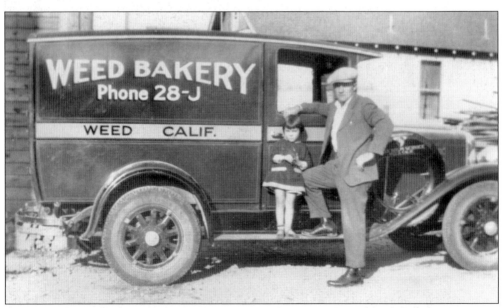

Paul Brunello came from northern Italy in 1922 to the town of Weed, California, near Mount Shasta, where he acquired the Weed Bakery in 1926. In 1957, he opened the El Real Bakery in Palo Alto and eventually expanded to a 15,000-square-foot facility in Mountain View. Paul's two sons, Roger and Dan, founded the Le Boulanger bakery chain in Los Altos in 1981. (Courtesy Dan Brunello.)

The Firato Deli was located at 28 East Santa Clara Street, next to the San Jose Safe Deposit Bank. Salamis, prosciuttos, and cheeses hung in the front window while Christina Firato made delicious raviolis, tortellinis, and sauces in the back kitchen. By the late 1960s, there were three generations of Firatos working side by side. The Firato Delicatessen closed in 1977. (Courtesy Al Firato.)

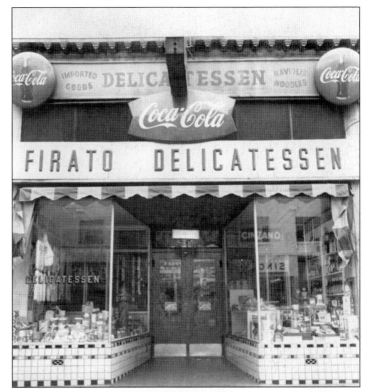

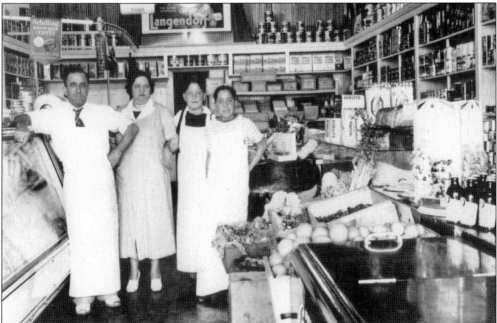

Carlo Firato is pictured here with his wife, Christina, and two sons, Al (Sonny) and Ray (right), in 1933. Carlo came from Penango, Italy, in 1910 via Ellis Island. After serving the United States in World War I, Carlo first went to Oakland where he worked at the famous Fiora D'Italia restaurant. He then moved to San Jose in 1922 and eventually opened his delicatessen. (Courtesy Al Firato.)

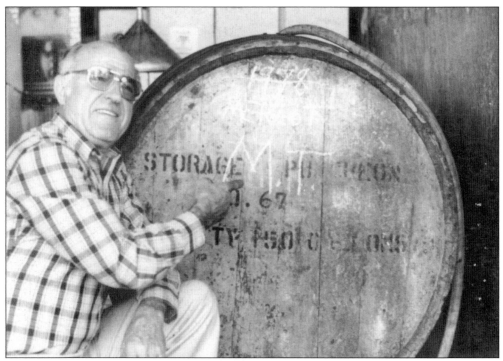

Mario Gemello, who took over the Gemello Winery from his father, John, in 1944, shows off a barrel of 1978 merlot. Mario retired and sold the business to his niece, Sandy Obester. This photograph was taken on the last day of the winery's operation in 1982. (Courtesy Kay Gemello.)

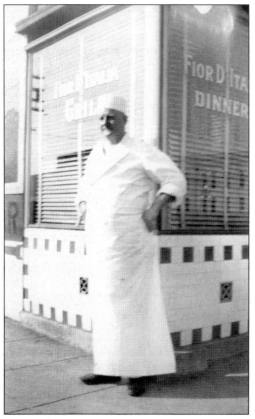

Peter Pianto stands in front of the Fior D'Italia restaurant at 101 North Market Street in San Jose in 1939. His family also owned the Italia Hotel, which served as a boarding house for Italian immigrant men. Other hotels in the area that were owned and run by Italians included the Torino Hotel, the Costa Hotel, the Genova Hotel, the New York Exchange, the Swiss Hotel, and the St. Charles Hotel. (Courtesy Paula Quinterno.)

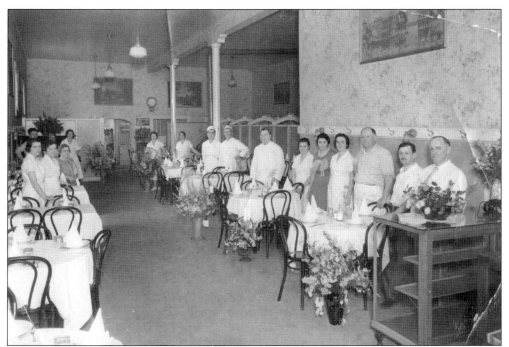

At far right are Italia Hotel co-owners John Pianto, Joe Mondora, and Peter Pianto. They are pictured in the hotel's basement restaurant called the Italian Cellar. The hotel was located where the Fallon House now stands on West St. John Street near San Pedro Street. Starting in 1962, the restaurant became Manny's Cellar, and it ran until about 1990. (Courtesy Paula Quinterno.)

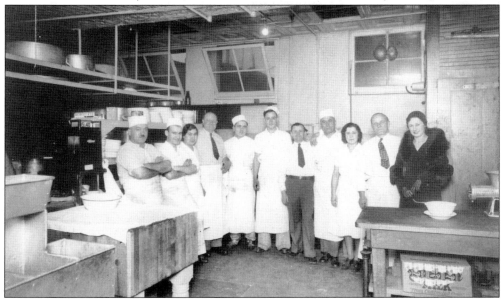

The Pianto brothers and the kitchen staff take a photograph in the Italia Hotel's basement restaurant. Customers could bring their own pots and fill them up with spaghetti and sauce for about $1. From left to right are Johnny the dishwasher, Alex ?, Bruna ?, Peter Pianto, unidentified, Tony Colla, Joe Mondora, Bruno the chef, Mary the waitress, John Pianto, and unidentified. (Courtesy Paula Quinterno.)

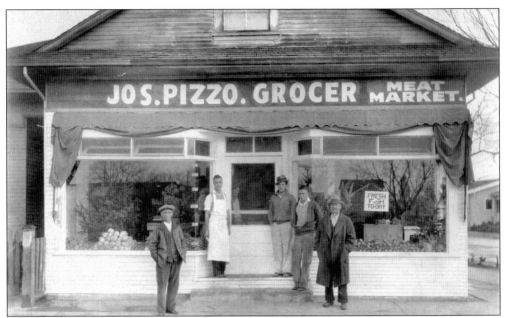

The Pizzo Grocer and Meat Market was located on Almaden Avenue and Goodyear Street, right in the heart of "Goosetown." From left to right are ? Mancuso, Vince Pizzo, Tony Pizzo, Peter Pizzo, and Joe Pizzo. George Pizzo is on the other side of the glass door. At one time, cattle were herded right down the middle of Taylor Street to the slaughterhouse at the end of the road. (Courtesy Terry Riola.)

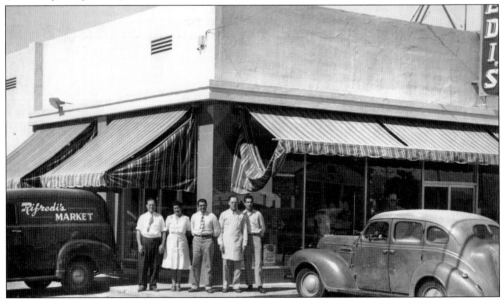

Rifredi's Market once stood where the Cupertino Post Office is currently located on Stevens Creek Boulevard. As a founding member of the First Valley Bank of Cupertino, which provided financial assistance to many local businesses and developers, Charlie Rifredi did much to help develop Cupertino during the 1950s and 1960s. Standing from left to right in 1949 are Charles Rifredi, Adriana Quinterno, Angelo "Cheet" Quinterno, Bill Ziegler, and Herb Chaboya. (Courtesy Paula Quinterno.)

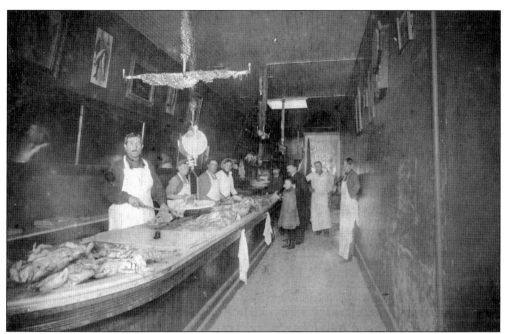

The American Fish Market at 38 Post Street in San Jose was owned by Frank J. Locicero Sr., who ran the market starting in 1880. Grandson Frank J. Locicero III remembers going once a week to San Francisco, Santa Cruz, and Monterey to buy fish from the many Sicilian fishermen at the wharfs. The market closed around 1955. (Courtesy Frank J. Locicero III.)

This is the logo of the American Fish Market, which was used on envelopes. In addition to fish, Locicero and the Caruso brothers sold poultry and vegetables. One of the services that the American Fish Market provided was delivery of fresh fish directly to people's homes. (Courtesy Frank J. Locicero III.)

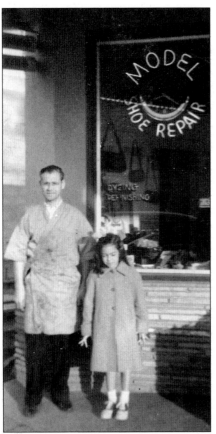

In the early 1950s, Sam Ferrara stands with his daughter Vera at his Model Shoe Repair on Dana Street in Mountain View. Vera grew up and married Aldo Girolami, who became a Stanislaus County Superior Court judge. In 2005, Vera Girolami became the first woman president of the California chapter of the Order Sons of Italy in America. (Courtesy Vera Girolami.)

Right next to Chiaramonte's Market at 609 North Thirteenth Street was the Sicilia Macaroni Company, owned by Vince Campagna, who, like Salvatore Chiaramonte, was also from Trabia, which is in the province of Palermo on the island of Sicily. It was said that at one point there were 12,000 people from Trabia living in Santa Clara County and just 5,000 living in Trabia! Marietta Campagna Sunseri, Vince's daughter, remembers working in the pasta factory as a child where she would put labels on the bags, then put the pasta inside, and glue the bags closed. The Sicilia Macaroni Company was the first to start using cellophane bags to pack dried pasta. From left to right are (children in front) Sam Cancilla and two Cancilla grandchildren; (adults) Sam Vitali, Naish De Mattei (Marietta's uncle), Vince Campagna, Philip Cancilla, ? Cancilla, Rose Cancilla, Caroline Campagna, and Frances Vizzini. (Courtesy Marietta Sunseri.)

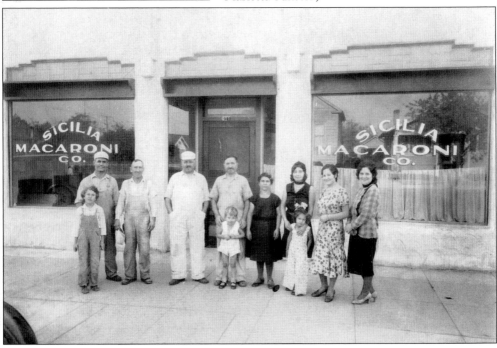

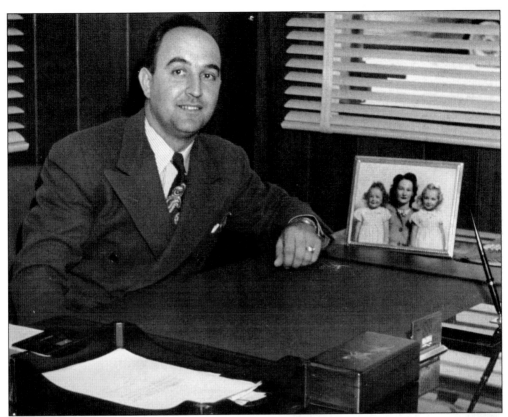

Edward S. J. Cali was the son of Rosario Cali, who immigrated to the Santa Clara Valley from Sicily in 1907. Ed helped his father expand the transportation division of R. Cali and Brother from 11 trucks to 96, covering much of Northern and Central California. Ed was a former president of the Cupertino Lions Club and vice president of the First National Bank of Cupertino. (Courtesy Ron Cali.)

Joe "Chickie" Cancilla was known as "Mr. Christmas Tree." In 1930, he became the first person to start selling Christmas trees in San Jose, which he did until his death in 1963. He was known for giving leftover Christmas trees to charitable organizations and for throwing a few onto bonfires for the St. Joseph's Day celebration held annually on March 19. (Courtesy Mae Ferraro.)

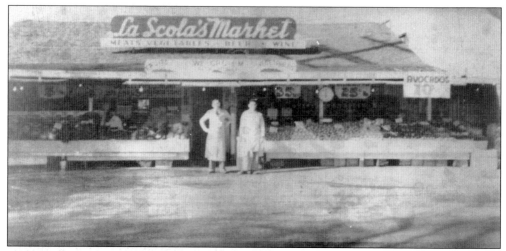

Phil Cosentino (right) stands with his uncle Joe La Scola in front of La Scola's Market, which started as a vegetable stand in 1947. Phil's father, Dominic Cosentino, who came from Sicily via Ohio, was the first owner. Located on Bascom Avenue, the market sold meats, fruits, vegetables, beer, and wine. The sign on the right indicates that avocados were 10¢. (Courtesy Phil Cosentino.)

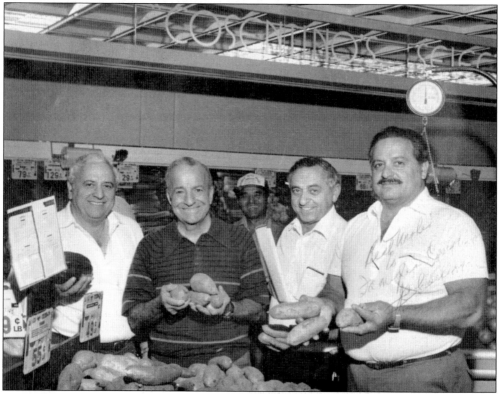

The Cosentino brothers built their business reputation on quality and customer service. By 1955, they had opened Cosentino's Vegetable Haven near Bascom and Union Avenues. Eventually the name was changed to Cosentino's Market. From left to right are Dominic Cosentino, Joe Cirincione, Phil Cosentino, and Marino Cosentino. A fourth brother, Sal, is not pictured. The man wearing the hat and big smile in the background is unidentified. (Courtesy Phil Cosentino.)

Ofc. Jimmy Guido of the San Jose Police Department gives a talk to the students at Benjamin Cory Elementary School in 1958. The child with the large grin pointing at the nice officer is John Guido, Jimmy's son. With such a great role model to learn from, it is no surprise that John grew up to become a policeman, just like his dad. (Courtesy James J. Guido.)

Sallina Cascio Lickwar is pictured here in 1970 with her superior Robert E. Nino, who was the chief juvenile probation officer for the Santa Clara County Department of Juvenile Corrections. Outside of work, Sallina was very passionate about opera and theater production. She and her husband, Nick, were also active members of the Italian American Heritage Foundation, which was founded in 1975. (Courtesy Nick and Sallina Lickwar.)

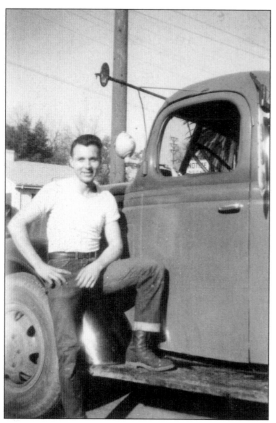

Al Scoffone started his trucking business in 1945 with one truck. The Scoffone Trucking Service (STS) later grew to a fleet of over 100 vehicles, becoming one of the largest and most diversified container-hauling companies in the Bay Area. It later became Athens Transportation Systems (ATS) and is today headed by Al's son David. (Courtesy Beverly Scoffone.)

Al Scoffone and his crew remove an old locomotive steam engine from the Santa Cruz Mountains sometime in 1964. It is thought that the locomotive was headed to the home of famed Southern Pacific railroad engineer Billy Jones, who used to work the rail line in the Santa Cruz Mountains. Italian American trucking concerns like Scoffone took on some of the most challenging jobs available. (Courtesy David Scoffone.)

Metal shops like Nicholas H. Russo's Sheet Metal hired Italian machinists who helped build dehydrators that were used in fruit packinghouses. Another machine shop that made equipment for the packinghouses was the Garbarino Machine and Iron Works, which was founded in 1928 by Paul Garbarino after he left the San Jose Foundry and Machine Shop, which itself was founded by Rocco Francia. (Courtesy Gary Rovai.)

The S. P. Cristina Plumbing Company dug the ditches and laid the pipes for city water and sewer systems. Around the time this photograph was taken in 1910, there were approximately 29,000 people in San Jose and 83,500 people in Santa Clara County. Today there are many construction companies that bear Italian names such as Ferma, Nibbi, De Mattei, and Sobrato, to name a few. (Courtesy Gary Rovai.)

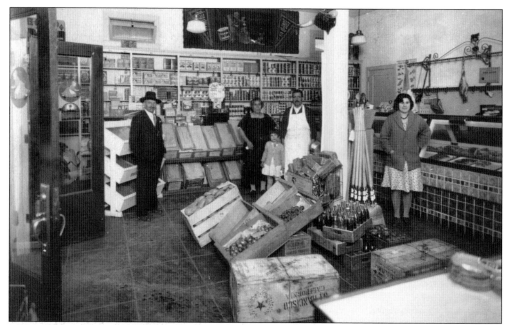

Chiaramonte's Italian Market, seen as it was in 1931, still stands in the same location in 2007 at 609 North Thirteenth Street. Originating from Trabia, Sicily, Salvatore Chiaramonte was a butcher by trade. He founded Chiaramonte's Italian Market in 1908. His great-grandson Louis Chiaramonte, who taught electronics for 39 years, has operated the store since 1985. (Courtesy Lou Chiaramonte.)

In 1943, Mario, Marino, and Etra Luci started the Gallo Macaroni Manufacturing Company on Willow Street, which was in the heart of "Goosetown," the Italian settlement that got its name from the many waterfowl that congregated along the Guadalupe River. Gallo Macaroni would eventually become a major producer of pasta products in California. (Courtesy Gary Rovai.)

Joe V. Salamida and his eight-year-old son John display some of their products for their family business in 1945. Joe started his shop in a neighbor's basement, where he made custom wood screens. He soon left P. M. Mill, where he worked, and started the Screen Shop. John Salamida has continued the business that his father created. (Courtesy John Salamida Sr.)

John Salamida (left) is seen with his father, Joseph, and his aunt, Christine Mannina, in 1964 in the office of the Screen Shop at 601 Hamline Street, the same location where the shop still stands today. John had just started in the family business two years earlier. John's grandfather, also named John, would be proud that his great-grandchildren continue to work for the Screen Shop. (Courtesy John Salamida Sr.)

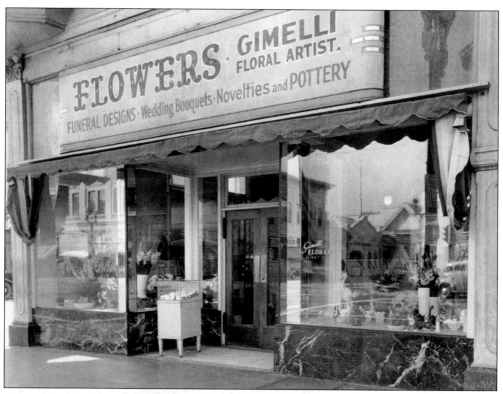

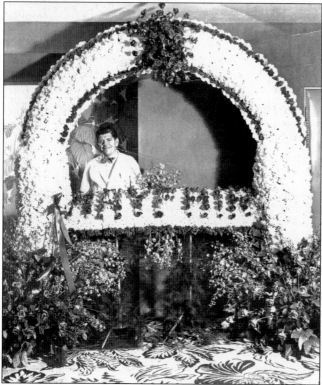

The Gimelli flower shop was located at Santa Clara and Third Streets in San Jose. Gene Gimelli was a floral artist, providing arrangements for weddings and funerals. His son Eugene did not follow in his footsteps but instead went into law enforcement, where he spent 31 years as a Santa Clara County deputy sheriff. This photograph was taken sometime in the mid-1940s. (Courtesy Eugene Gimelli.)

Gene Gimelli shows off his floral creation for the grand opening of the Mayfair Theatre in San Jose in 1950. The Mayfair was a small movie theater that has since become an athletic club on Second Street. (Courtesy Eugene Gimelli.)

Considered the master of accordion instruction in California, Louis Figone started his Figone Accordion School in San Jose in 1934. It became one of the largest accordion bands and schools in California. Figone was famous for driving his students around on the back of a truck in local parades. Unfortunately, the popularity of the accordion declined precipitously once the guitar hit the scene in the early 1960s. (Courtesy Marilou Cristina.)

Louis Figone (right) stands with Angelo Sparacino in the Figone Music Company's Accordion Center booth at the Santa Clara County Fair in 1951. A sign next to Louis promises to give 10 free lessons to the person who wins one of his 12 bass accordions on display. Accordion configurations start at the 12 bass range and go up to 140 bass. (Courtesy Marilou Cristina.)

Federico Quinterno built this Grecian-style water tower on the Seven Springs ranch, which was owned by the Radford family. His talents as a stonemason were in great demand by wealthy patrons. Note the three men at the top of the steps. Behind the man sitting down is a lion's head fountain. Apparently, there was also a moat that surrounded the structure, which still stands today. (Courtesy Paula Quinterno.)

The Hawaiian Gardens opened in 1933 as Lo Curto's Gardens, owned by rancher John Lo Curto. Located at 1500 Almaden Road, the restaurant/nightclub sat on nine acres and had a grotto inside that had trained bullfrogs. Before ending as the Italian Gardens, the nightclub went through several incarnations. Seen here is a matchbook cover that depicts the famous frogs and swans that populated the rock-bordered pools found throughout the property. (Courtesy Ed Fontaine.)

Six

GOOD SPORTS

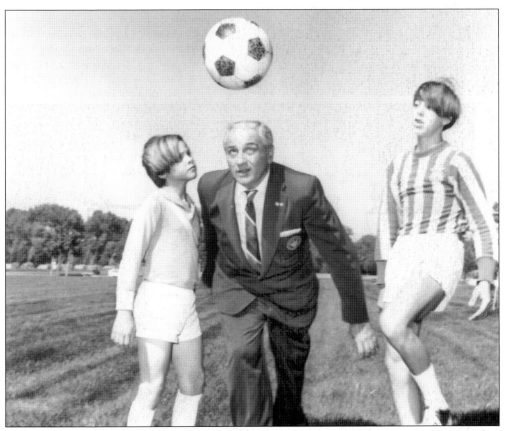

Umberto Abronzino is considered the father of soccer in Santa Clara County. He arrived in San Jose in 1953 from Connecticut, and by 1957, he had created the Peninsula Soccer League, which started with four adult amateur teams and eventually grew to more than 100. The most competitive youth league in the Bay Area is called the Abronzino League, named in his honor. (Courtesy Linda Abronzino.)

Umberto Abronzino is pictured here with Pelé and an unidentified representative for MasterCard at the World Cup in Los Angeles in 1994, where he was given the honor of MasterCard Ambassador of Soccer for Italy. In 1971, Abronzino was inducted into the National Soccer Hall of Fame in recognition of his dedication to nurturing the sport of soccer in the United States. (Courtesy Linda Abronzino.)

Founder of the San Jose Police Activities League (PAL), Det. Jimmy Guido (left) consults in 1976 with the man "of May," which is what DiMaggio's name literally means in Italian. DiMaggio allowed Detective Guido and PAL to use his name for the Joe DiMaggio Baseball League, which was the youth baseball equivalent to the Abronzino League for youth soccer, with both leagues showcasing the best players. (Courtesy James J. Guido.)

According to Louis Bonino of Gilroy, one of the Italian boys from this 1924 San Martin grammar school baseball team, with only an eighth-grade education, went on to become president of Safeway Foods. His name is believed to be Louis Bianchi. In farming communities like San Martin, kids were needed to help on the farm. This boy was so smart that the teacher would ask him for help. His desire to succeed must have been great. (Courtesy Louis Bonino.)

Coach Nick Ferraro (far right, back row) stands with his Little League baseball team in 1956. In 1982, Nick was honored by his players as "Manager of the Decade" for the lessons of sportsmanship and love of the game that he had taught them. The plaque that they gave him read: "Nick Ferraro, Manager of the Decade, With Love and Gratitude, From Your Kids 25 Years Later." (Courtesy Mae Ferraro.)

Hank Aiassa had a drive-in grocery market on First and Julian Streets in San Jose, and he also sponsored a nighttime baseball club. Aiassa Stores was the championship team in 1931. Nick Ferraro (kneeling at far right in this newspaper photograph) would later coach his own Little League baseball team (pictured on page 93). (Courtesy Mae Ferraro.)

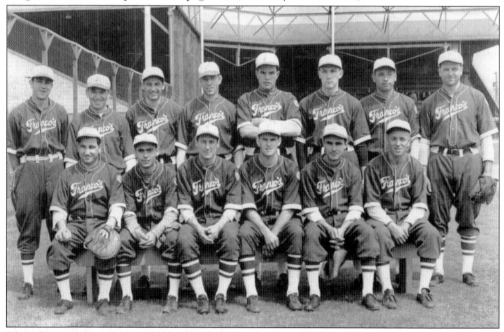

This photograph is presumed to be of members who played for Joey Franco's PW Market baseball club in the 1940s. Joey Franco came from Italy in 1921 and began working in the orchards around the Santa Clara Valley picking apricots and prunes. His dream to have his own grocery store came true. At last count, there were nine PW Market stores. (Courtesy Buzz Erena.)

During the 1940s and 1950s, bike racers, like the Gatto brothers and Joe Colla, who was a pharmacist and San Jose City councilman, competed at the Garden City Velodrome in the Burbank section of San Jose. Competitive bicycling once drew many spectators but began to decline after World War II. Here Al Scoffone is preparing himself for a bike competition at an unknown location. (Courtesy David Scoffone.)

Nick Chiechi shows good form in his boxing stance. In the 1930s, prizefighting was a way for Italian immigrants to earn money, despite the dangers. Though times were tough, Nick shows that he had the right stuff. He was good friends with slugger Jack Dempsey, who became the godfather of Nick's son Michael. (Courtesy Marge Chiechi.)

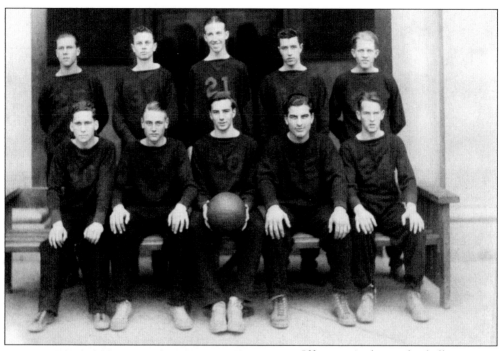

If he wasn't playing football or wrestling his opponents to the mat, Sam Della Maggiore could be found on the basketball court. Here Sam, seated second from right, is pictured with teammates from the San Jose High School basketball team around 1930. (Courtesy Gene Della Maggiore.)

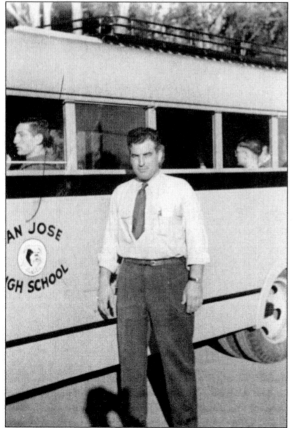

In addition to his duties as coach of the wrestling, swimming, water polo, and tennis teams at San Jose High School, Sam Della Maggiore became the wrestling coach at San Jose State University in 1940. During his high school coaching career, Sam's wrestling teams placed first in the city's high school wrestling league 19 years straight, which happened to be the length of his career as a coach at San Jose High. (Courtesy Gene Della Maggiore.)

Mario Mastrocola's wife, Marjorie, and son, Philip, present him with the first pair of soccer shoes that he ever owned when he played soccer in Italy. His family had the shoes restored and presented them to him as a gift for his birthday. When Mario became the first soccer coach at Bellarmine College Preparatory in the late 1960s, he taught his players how to love the game of soccer and what it meant to be members of a team. (Courtesy Michael Mastrocola.)

The first members of Bellarmine's Hall of Fame for soccer attend a ceremony for their induction. From left to right are Michael Mastrocola, Rob Micheletti, Tom Biagini, Tom McMacken, Lenny Danna, and coach Mario Mastrocola. Mario came to America in 1948 from Rome, Italy, where he was an outstanding soccer player. He had careers as both a soccer coach and a travel-industry representative. (Courtesy Michael Mastrocola.)

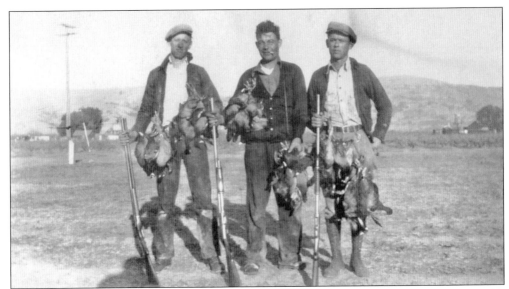

Matt Pedrizzetti (left), Frank Cordona (center), and Tony Bonino show off their quarry in 1933. When Italian winemakers and farmers like Pedrizzetti and Bonino got together for a hunting excursion, fowl did not stand a chance against this poetic Italian combination that cherished the bounty of the land. They are a reminder of the humanity that was once prevalent in the Valley of Heart's Delight. (Courtesy Louis Bonino.)

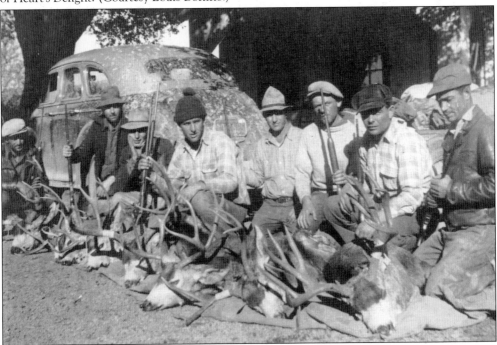

The boys from Gilroy bag some big bucks in 1936. Some of those included in the photograph are Buster Mangano, Tony Bonino, Frank Cordona, and Carmen Triffulo. One can be sure that these friends wasted no part of the catch. Today the march of technology and progress has created a new culture that hunts for the next new thing and throws away whatever does not shine. (Courtesy Louis Bonino.)

Seven

IT'S A WONDERFUL LIFE

Grande Festa Annuale
Di Frinco
DATA DALL' ORCHESTRA ARDITA DI OAKLAND

Sunday
SEPT.
9
1934

Nel
Matasci
Ranch
DOWNER AVENUE
Sull' ALMADEN
ROAD
San Jose

Ardita Orchestra—Radio Station KROW—Oakland California

GRANDI AVVENIMENTI
Squisito Pranzo e Cena Servito Dal Signor Firato

During the 1930s, Carlo Firato of the Firato Deli organized the Festa di Frinco. The writing below the photograph says, "Big Events. Delicious Dinner and Supper. Service by Mr. Firato." The festa, held on the Sunday before Labor Day, included musical entertainment. The Ardita Orchestra could be heard on Oakland's KROW radio during the Italian Hour, which was popular in the 1930s. (Courtesy Al Firato.)

Matasci Ranch was a popular picnic spot for members of the Italian community. Sal and Sara Guido are pictured here at the ranch sometime in the 1930s. Sal came from the town of Meta, near Naples. Sara came from a town in Sicily called Piana degli Albanesi, whose Albanian-speaking inhabitants were known as Arberesh. The Arberesh, whose dialect is also called Arberesh, immigrated to Sicily in the 1500s. (Courtesy Gene Guido.)

Angelo Bellicitti is with his wife, Isabella, in Alum Rock Park in 1917, a few years before their son Harry was born. The park's beautiful scenery and mineral springs attracted many members of the Italian community for picnics and club gatherings. Having one's picture taken was not as common as it is today. It is amazing that there are images from this earlier period in the valley's history. (Courtesy Harry Bellicitti.)

A. P. Giannini and his bride, Clorinda Cuneo, were both 22 years old when they got married in 1892. Clorinda's father, Joseph Cuneo, was a director with the Columbus Savings and Loan Society in San Francisco. After he died, A. P. was given his seat on the board. However, a dispute with the bank over its refusal to lend to Italian immigrants led A. P. to found the Bank of Italy in 1904. (Courtesy Virginia Hammerness.)

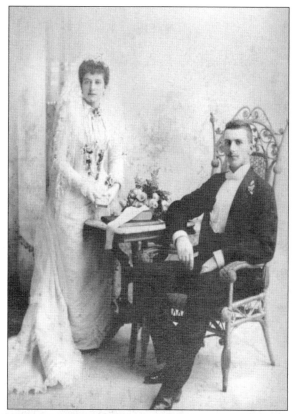

Sitting on the horse at left at the back of the wagon is A. P. Giannini. His wife, Clorinda, is the woman standing in back wearing the dark hat. A. P.'s son Virgil is sitting in front next to his older brother Lawrence Mario. The young girl sitting near the back was A. P. and Clorinda's only daughter, Claire, who went on to become a director at the Bank of America. (Courtesy Virginia Hammerness.)

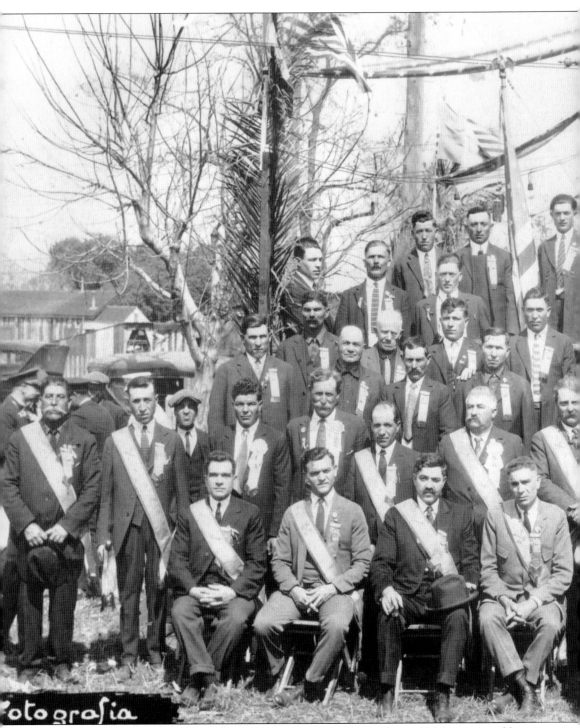

otografia

Sitting to the right of the priest in the front row is Dismo Denegri, a former California assemblyman, member of the San Jose City Council, and the founder of the Loyal Italo-American Club. This photograph was taken in March 1925 at the Sacred Heart of Jesus Parish for the St. Joseph's Day festival, which ran from March 19 to 22. The club's stated purpose was to bring Italians together

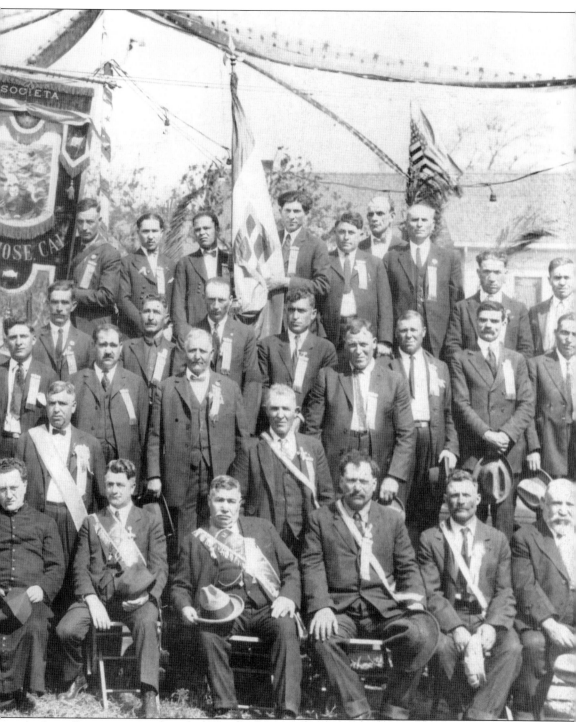

and instill a respect and admiration for American institutions. In addition to Dismo Denegri as president, other organizers were D. Campisi, Frank Ruiz, Frank Cavallaro, and C. D. Cavallaro. This club continues today as the San Jose Civic Club. (Courtesy Gary Rovai.)

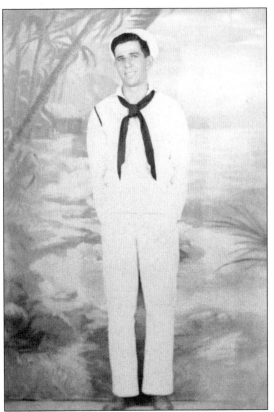

Adolph De Mattei, who grew up on Taylor Street in the predominantly Italian neighborhood of San Jose, served 30 months in the navy in World War II. Adolph got into the produce business after the war ended and worked for the Petroni Vegetable Market and Joey Franco's PW Market chain for a quarter of a century. (Courtesy Adolph De Mattei.)

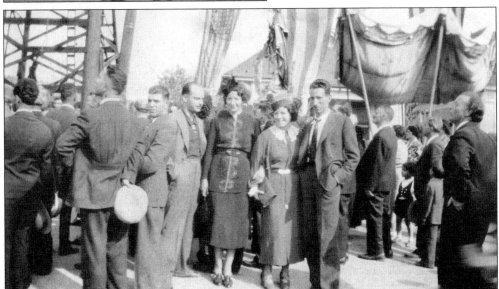

The Golden Gate International Exposition on Treasure Island in 1939 was a popular destination for Italian families like the Chiechis. Ironically, after World War II started, about 100 Italian nationals who were attending the expo were detained and sent to internment camps at Fort Missoula, Montana. Many Italian prisoners of war would also be kept at Fort McDowell on Angel Island in the San Francisco Bay. (Courtesy Marge Chiechi.)

Celestine "Sally" Gemello Traverso referred to these young ladies as the "Apricot Girls." She recalled that they would come down to the valley from San Francisco to vacation during the summers. In this photograph taken in 1931, two of the girls seem to be in the midst of a friendly pulling competition while one plays the role of referee and two others provide cheerleading support. (Courtesy Sally Traverso.)

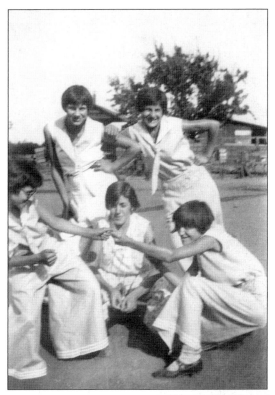

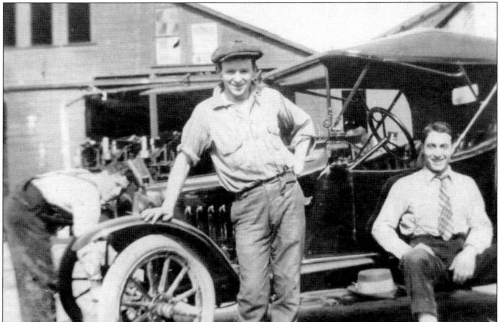

Philip Barbaccia, who is believed to be sitting at right, takes a break on his new 1920 Ford, probably a Model T. Philip came to the valley from Sicily in 1907 when he was 13 years old. By the time he bought his Ford in 1920, Philip and his younger brother Nicholas would gather enough capital to form the Santa Clara Valley Canning Company. (Courtesy Lou Barbaccia.)

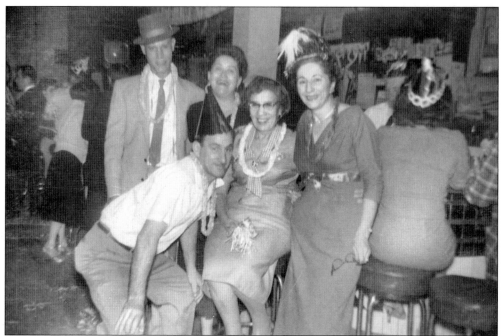

Bini's was the place where many of the cannery workers and produce growers would eat breakfast and lunch. In later years, the clientele grew to include professionals and office workers. After her husband died in a tragic plane crash, Edith Bini Williams took over running the restaurant. Here, in 1955, Edith Bini Williams (right) rings in the new year with friends. (Courtesy Edith Bini Williams.)

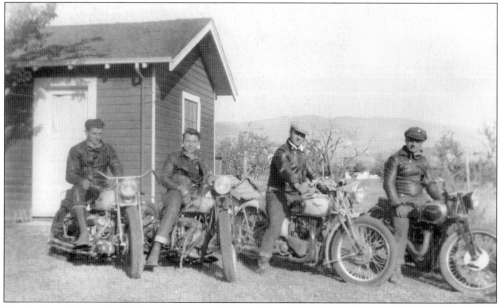

The leader of the pack, Al Scoffone, second from left, relaxes with a few members of his weekend motorcycle touring club sometime in the late 1940s or early 1950s. The bike brands include Triumphs, Ariels, Harleys, and Indians. The Triumph brand received good publicity once Marlon Brando rode one in the 1953 hit movie *The Wild One*. (Courtesy David Scoffone.)

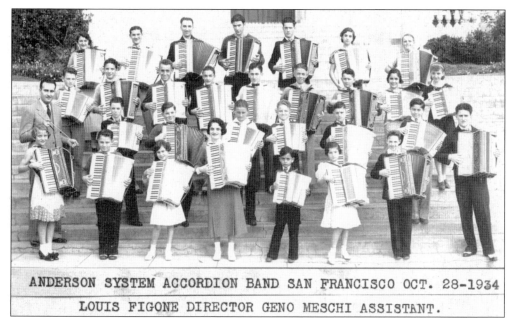

ANDERSON SYSTEM ACCORDION BAND SAN FRANCISCO OCT. 28-1934
LOUIS FIGONE DIRECTOR GENO MESCHI ASSISTANT.

Louis Figone had just established the Figone Accordion School in 1934, the same year this photograph was taken. Not only did he have his own school, he was director of the Anderson System Accordion Band, which had one of the world's largest accordion bands at more than 200 players. Here Louis leads his students in a performance somewhere in San Francisco. (Courtesy Marilou Cristina.)

Cesare Girolami, on bended knee in 1925, ran the St. Charles Electric Company of San Jose. His son Aldo Girolami became a Stanislaus County Superior Court judge. The woman holding the sword is Aida Bianchi Pesterino, the mother of Marilyn Pesterino Zecher, who was also a Santa Clara County Superior Court judge. The man at right is identified as a Mr. Pezzini. (Courtesy Al and Vera Girolami.)

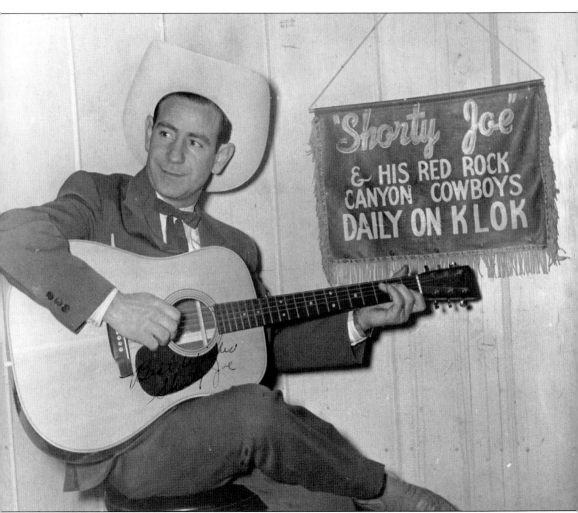

Country-western talent "Shorty" Joe Quartuccio came to San Jose from Monreale, Sicily, in 1936 when he was just a child. After working long hours in one of the many canneries around San Jose, he would listen with his friends to Dude Martin and His Nevada Night Herders on KLX radio from Oakland. This inspired him to form his own group, which they called "Shorty Joe and His Red Rock Canyon Cowboys." After some time, Joe had his own radio broadcasts on KLOK and KEEN, which was located in the old De Anza Hotel on Santa Clara Street. (Courtesy "Shorty" Joe Quartuccio.)

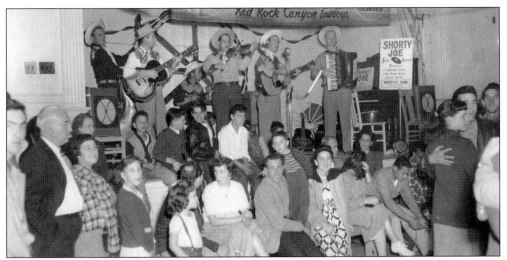

Shorty Joe and His Red Rock Canyon Cowboys perform at the former Tracy Gardens for the Columbus Day Dance in 1950. The Franklin Mint Record Society included Shorty Joe's "Saturday Night Stomp" in a collection of the greatest country music hits of all time. Shorty Joe and his band often accompanied such notable acts as Hank Williams, Kitty Wells, Hank Snow, Ernest Tubb, Tex Williams, Lefty Frizzell, and many of the Grand Ole Opry stars of the 1940s and 1950s. (Courtesy "Shorty" Joe Quartuccio.)

In 1938, Anthony Quartuccio drew this sketch at the Gilroy Gymkhana for the *San Jose Mercury Herald*. Anthony was just 15 years old at the time, and he was crazy about cowboys, bronco busting, bull riding, and calf roping. The Madrone Rodeo and the Gilroy Gymkhana were the big events of the day in the south county. (Courtesy Anthony Quartuccio Sr.)

With a large prickly pear cactus patch providing the backdrop, Anthony Quartuccio looks like he could have been an extra in a Sergio Leone film like *The Good, the Bad, and the Ugly* or *A Fistful of Dollars*. The kid from Monreale, Sicily, has used his God-given talents to express the beauty that surrounded him in the Valley of Heart's Delight through many drawings and paintings. (Courtesy Anthony Quartuccio Sr.)

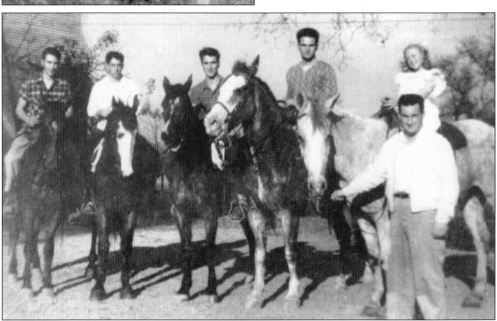

Getting ready to head out in 1945 for the Early Settlers' Day parade in Campbell are, from left to right, Lou Barbaccia, Tony Raffante, Eddie Bersana, Joe Benevento, Frankie Pecoraro, and an unidentified girl. The Campbell parade started in 1892 as a way for farmers and friends to spend more time together since they were always busy working on their farms. (Courtesy Lou Barbaccia.)

The Figone Accordion Club of San Jose performs at one of many events in 1950. By the time the Beatles arrived in America in the 1960s, interest in learning how to play the "concertina," which was what the Italians called the accordion, had waned. Still, there are some clubs that continue the tradition. It is without question one of the most melodic and harmonic instruments around. (Courtesy Marilou Cristina.)

Master accordionist, teacher, and music publisher Louis Figone, far right, is seen with a group that he played with for a radio show in the early 1930s. Sitting next to Figone is Angelo Sparacino, who later taught accordion at Figone's accordion school, which became known as the "accordion headquarters for the Santa Clara Valley." (Courtesy Marilou Cristina.)

Gaspare Riga was born in Italy in 1891 and fought for the United States in the First World War. He settled in Oakland, where many Italian immigrants arrived by train from the East Coast. Gaspare was known to spend his vacations working in his garden in the backyard. (Courtesy Lou Riga.)

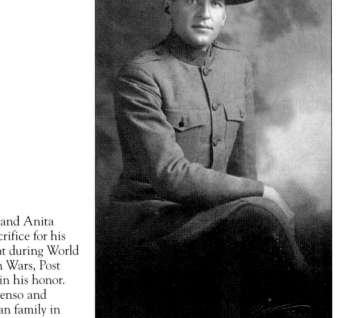

Virgil Picchetti, son of Antone and Anita Picchetti, made the ultimate sacrifice for his country when he died in combat during World War II. The Veterans of Foreign Wars, Post 9803 of Cupertino, was named in his honor. Virgil's grandparents were Vincenso and Teresa Picchetti, a pioneer Italian family in Cupertino. (Courtesy Tish Picchetti.)

Dr. Rudy Melone, right, and his wife, Gloria, who is wearing a crown of garlic, started the Gilroy Garlic Festival in 1979. Dr. Melone was inspired by the garlic festival in Arleux, France, which claimed to be the "garlic capital of the world." In 2000, over 4,000 volunteers from 163 nonprofit groups worked 42,130 hours to host the 22nd Annual Gilroy Garlic Festival. (Courtesy Dr. Gloria Melone.)

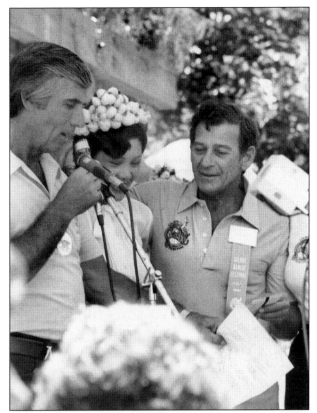

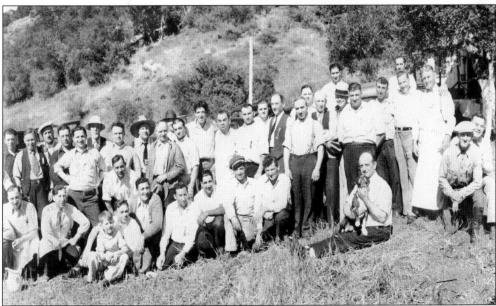

Members of another Italian social club, the North Star Social Club, are seen here in 1936. The location is probably Alum Rock Park, a popular place for outdoor gatherings and picnics. This photograph is part of a much longer panoramic shot that included many more people. Fun and friendship was part of the atmosphere wherever Italians gathered. (Courtesy Gary Rovai.)

By the 1960s, the Festa di Frinco was held at Alpine Park on Canoas Road. After World War II, Italian culture had suffered a large setback and fewer people felt comfortable speaking Italian in public. The stigma of the "enemy alien" episode during the war took its toll on members of the Italian community. The group providing entertainment for this Festa di Frinco was Bagnasco's Orchestra. (Courtesy Al Firato.)

Here Sallina Cascio Lickwar, second from left, poses with members of the *La Traviata* cast in the 1970s at what was then the Scottish Rites Temple. Sallina was considered a coloratura soprano, which was a little higher than mezzo-soprano, and opera was her passion. (Courtesy Nick and Sallina Lickwar.)

Hector, Virgil, and Aldo (from top to bottom) are the sons of Antone and Anita Picchetti. Their father, Antone, who was born in 1884 on the Picchetti ranch on Montebello, was himself the oldest of four brothers—John, Attilio, and Hector. The boys are seen here in their sailor suits sometime in the late 1910s or early 1920s. Hector Picchetti still lives in Cupertino. (Courtesy Hector Picchetti.)

Here is Margie Chiechi with her dog in 1956 in what could be her very own "secret garden." San Jose was in fact known as the "garden city," and with so many orchards and farms, it was an idyllic place to raise children. By the time Margie went to college, one of her summer jobs was working in a local cannery to earn extra money. (Courtesy Marge Chiechi.)

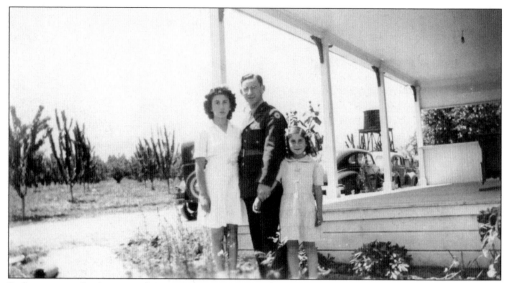

Italians were the largest ethnic group to serve in the U.S. Armed Forces during World War II. The irony is that while they were honorably serving their country, their friends and families were being singled out as "enemy aliens" who were placed under suspicion just for being of Italian descent. Here Anthony Quartuccio stands with his wife and daughter on the old Marchese ranch. (Courtesy Anthony Quartuccio Sr.)

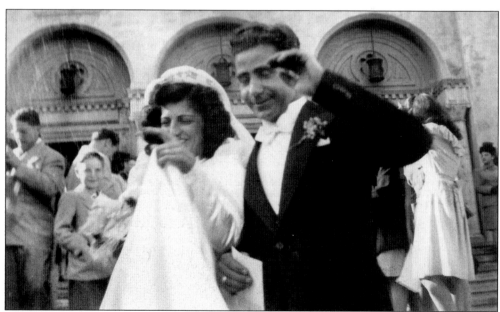

Jenny and Joe Quartuccio got caught in a rice rainstorm coming out of what looks to be Holy Cross Church in San Jose. The war was over, and it was time to get back to living life and raising families. It was at this time that the *dolce far niente* days of the Valley of Heart's Delight began to recede. (Courtesy Joe Quartuccio.)

Members of the Chiechi family are seen here at the Lick Observatory on Mount Hamilton in 1935. The artist Anthony Quartuccio wrote in his book *Santa Clara Valley, California: An Artist's View—Today and Yesterday* that Mount Hamilton was to him a symbol of the Santa Clara Valley. He described the silvery dome of the Lick Observatory as a sentry watching over the valley. (Courtesy Marge Chiechi.)

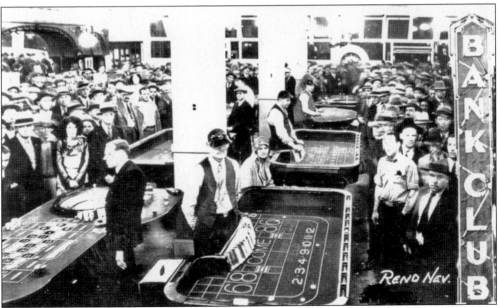

During World War II, many Italians served the United States by building barracks and military facilities around the country. Nick Chiechi sent this postcard home to his family in San Jose during the many months he was separated from them. Sunday was usually a day for Italian laborers to take a break and roll the dice in Reno, Nevada. (Courtesy Marge Chiechi.)

Det. Jimmy Guido of the San Jose Police Department finds himself being handcuffed after he picked up actors Paul Picerni (left) and Michael Dante at the San Jose Airport in 1972. The purpose of the visit was a three-day celebrity softball game sponsored by the San Jose Police Activities League. The game was a big fund-raiser for youth activity programs. (Courtesy James J. Guido.)

Returning the favor for the mock arrest at the airport, Detective Guido throws a fake punch at actor Paul Picerni, who played Lee Hobson, the assistant to Elliot Ness in the television hit series *The Untouchables*, from 1960 to 1963. After members of the Italian community complained about the rampant stereotyping of Italians as gangsters in the show, the Hobson character was created to placate complaints. (Courtesy James J. Guido.)

Sallina Lickwar, top center, performs with her quartet for the Policeman's Ball in 1954. She and her husband, Nick Lickwar, were very involved in theater production and performance. It is worth mentioning that Nick Lickwar was a great supporter of Italian heritage and culture and served one term as president of the Italian American Heritage Foundation in San Jose. (Courtesy Nick and Sallina Lickwar.)

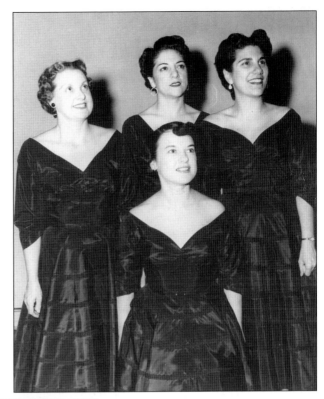

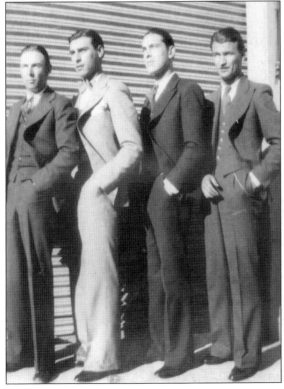

At far right is Bruno Rovai, the father of Gary Rovai, owner of the Goosetown Lounge in Willow Glen. Gary's Italian grandparents told him many colorful stories about "Goosetown," the Italian enclave located adjacent to where Willow Glen stands today. Superior Court judges, physicians, lawyers, college professors, teachers, merchants, businessmen, and a few millionaires got their start in Goosetown. (Courtesy Gary Rovai.)

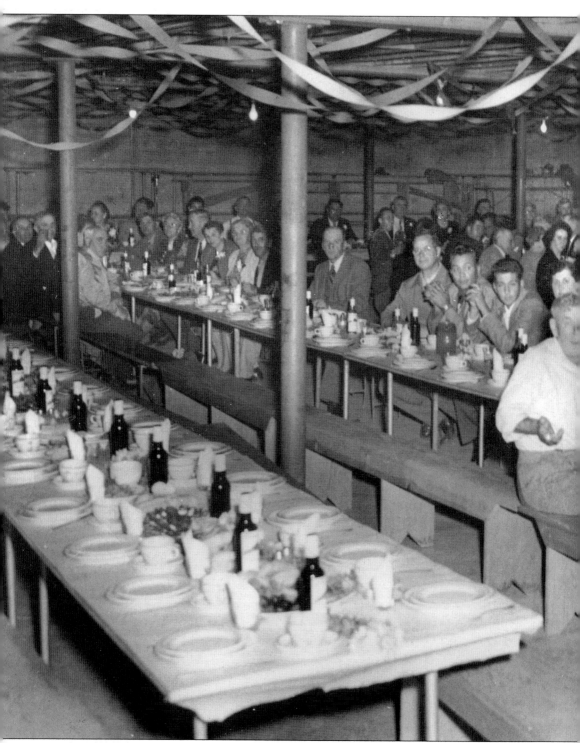

Saturday night at the SunnyView Club in Mountain View was the place to be for members of the Italian community. Many people came down from San Francisco to the "country" to socialize and enjoy the fresh air of the Valley of Heart's Delight. The club was going strong in the 1950s

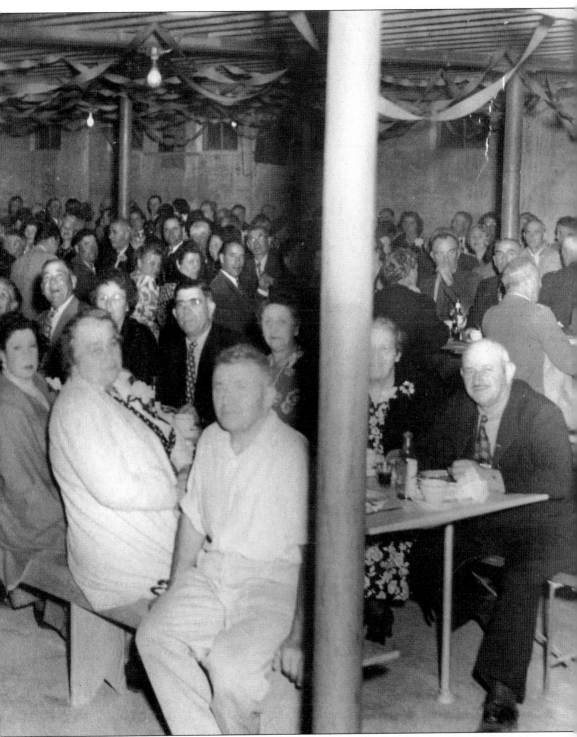

when a new wave of immigrants from Italy came to the United States. As seen in this photograph, people would eat downstairs and then go upstairs for dancing. The setup was simple; good people and good food were what mattered most. (Courtesy Carlo and Rose Marenco.)

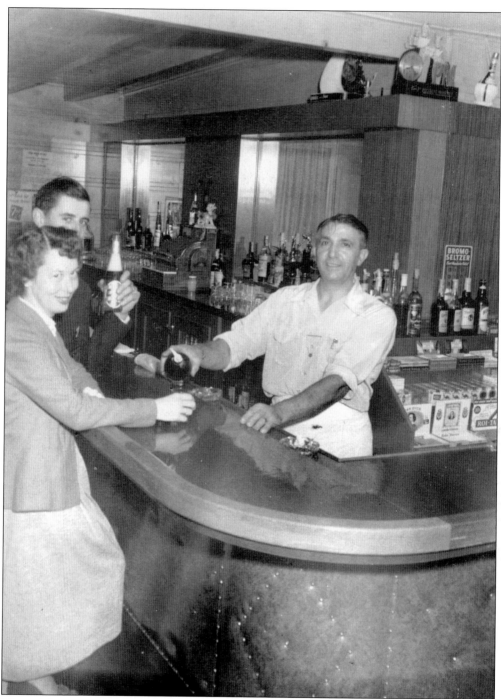

Marco Marenco, the first manager of the SunnyView Club in Mountain View, pours a drink for Peggy Costa in 1950. Peggy is with her husband, Mario, who owned the Costa Flower shop. Incidentally, the name of the SunnyView Club was derived from Sunnyvale and Mountain View. The new Senior Center on Escuela Avenue in Mountain View stands where the SunnyView Club used to be. (Courtesy Carlo and Rose Marenco.)

Tony Bonino (far left) stands next to his new bride, Helen, whose twin brother, Art Sgheiza, is standing with his bride, Jenny Costa. Tony was born in 1908 in a mining town in Bingham, Utah, before moving to San Martin as a child. His wife, Helen Sgheiza, was born in Salinas to a Swiss-Italian dairy-farming family. Here they look as sharp as any Hollywood movie star ever did. (Courtesy Louis Bonino.)

Tony Bonino, far right, shows off his new 1931 Chevy Roadster. From left to right are Ernest Camino, Frank Lepera, and Carmen ?. Tony came with his family from the Bingham mines in Utah and settled in Gilroy. He was born in 1908, and by 1931, at the age of 23, he purchased his first new car for around $700. (Courtesy Louis Bonino.)

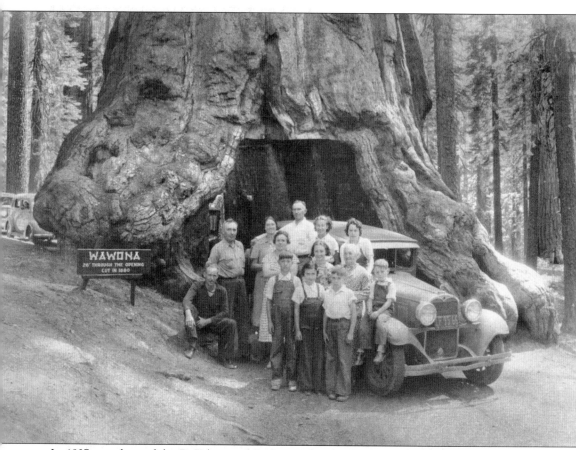

In 1937, members of the DePalma and Barbaccia families took a trip to Yosemite and snapped this picture at the famed Wawona Tunnel Tree. From left to right are (first row) Nicky Barbaccia, Rosemary DePalma, Leonard Michael DePalma, and Vincent DePalma; (second row) Rosalie Naso DePalma, Marie DePalma, and Nanzarem Barbaccia Naso; (third row) Dominic Naso, Michael DePalma, Rosalie Barbaccia DePalma, Norman DePalma, Jane Leo Lemos, and Catherine Naso Baiocchi. (Courtesy Marie Volp.)

In the 1930s in San Francisco, John Sobrato, the father of real estate developer John Albert Sobrato founded John's Rendezvous Club Restaurant de Luxe. The elder Sobrato served as a cook for officers in the U.S. Army during the First World War, and his service earned him a Purple Heart. The menu seen here was a special dinner in celebration of the football game between Stanford University and Santa Clara University. (Courtesy John A. Sobrato.)

John Albert Sobrato dines out with his mother, Ann, and father, John, sometime in 1952. Not long after, John's father passed away, and his mother sold the John's Rendezvous restaurant for $75,000 and began investing in real estate. Her only son, John Albert, began selling real estate when he was 18 years old while attending Santa Clara University three days a week. (Courtesy John A. Sobrato.)

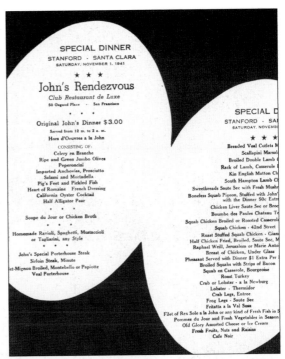

At one time, it looked like Anthony Quartuccio Jr. might become an artist just like his father, Anthony Quartuccio Sr., who is famous for his many beautiful landscape paintings of the Santa Clara Valley. The painting in this photograph is called *Redwood Morn* and shows the giant redwoods of Big Basin that Anthony Sr. painted. Anthony Jr. has since become music director and conductor for the South Valley Symphony. Incidentally, the word for teacher in Italian is "maestro." (Courtesy Anthony Quartuccio Sr.)

A modern-day Geppetto, Lou Muraco has created thousands of toys with his own two hands. A bricklayer and cement finisher by trade, Lou made his first Model T Ford toy for his wife in the early 1950s. Since then, he has made about 120 different models of toys using mostly California redwood. Lou is pictured here in 1987 in his backyard studio in San Jose. (Courtesy Lou Muraco.)

During the period of mass immigration from Italy to the United States, many Italians arrived with the intent of eventually returning home to Italy. But as they made friends and started families, they slowly began to see America as their new home. Sebastian Chimenti received his Certificate of Naturalization in 1956 after declaring his intention to reside permanently in the United States. Thousands of Italians did the same. (Courtesy Lucille Basso.)

ACROSS AMERICA, PEOPLE ARE DISCOVERING SOMETHING WONDERFUL. *THEIR HERITAGE.*

Arcadia Publishing is the leading local history publisher in the United States. With more than 3,000 titles in print and hundreds of new titles released every year, Arcadia has extensive specialized experience chronicling the history of communities and celebrating America's hidden stories, bringing to life the people, places, and events from the past. To discover the history of other communities across the nation, please visit:

www.arcadiapublishing.com

Customized search tools allow you to find regional history books about the town where you grew up, the cities where your friends and family live, the town where your parents met, or even that retirement spot you've been dreaming about.